QUILTS

CONSCIENCE OF THE

HUMAN SPIRIT:

THE LIFE OF NELSON MANDELA

Tributes by quilt artists from
South Africa and the United States

Marsha MacDowell and Carolyn L. Mazloomi

A collaborative project of Michigan State University
Museum, Women of Color Quilters Network, and
South African quilt artists

CONTENTS

1. Intuthuko Embroidery Group artists with Hester Viles
2. Tambani Project artists with Jenny Hearn
3. Regina Abernathy
4. Allyson E. D. Allen
5. Reneé M. Allen
6. Karin Arbeter
7. Gwendolyn Aqui-Brooks
8. Elaine Barnard
9. Helga Beaumont
10. Carol Beck
11. Julius J. Bremer
12. Carole Richburg Brown
13. Dorothy Burge
14. Bisa Butler
15. Helen Butler
16. Cynthia H. Catlin
17. Marí Claasé
18. Andrena Stoddard Coleman
19. Marion Coleman
20. Laura Croom
21. Carolyn Crump
22. Adriene Cruz
23. Celia de Villiers and Talking Beads
24. Jacqueline Dukes
25. Elmira Essex-Sizemore
26. Ife Felix
27. Deborah Fell
28. Michelle Flamer
29. Kathryn Harmer Fox
30. Marjorie Diggs Freeman
31. Laura R. Gadson
32. Pamela George-Valone
33. Jeanette Gilks
34. Rose Mary Green
35. Sandra M. Hankins
36. Colleen Harris
37. Peggie Hartwell
38. Jenny Hearn
39. Jenny Hermans
40. Mayota Willette Hill
41. Marla A. Jackson with Kearston Mahoney, Sommer Ferguson, Tori Mitchell, Sylvan Mitchell, Teagan Harmon, Desiree Powell, Nia Rutledge, Bella Myers, and Breanna Bell
42. Jacqueline Johnson
43. Gloria Kellon
44. Sharon Kerry-Harlan
45. Jill Krog
46. Betty Leacraft
47. Cynthia Lockhart
48. Sandra MacGillivray
49. Madeline Marsburg
50. Barbara Ann McCraw
51. Annette McMaster
52. Harriette Alford Meriwether
53. Patricia A. Montgomery
54. Barbara Murray
55. Phina Nkosi and Vangile Zulu
56. Sandra E. Noble
57. Marlene O'Bryant-Seabrook
58. Valarie Pratt Poitier
59. Glenda Richardson
60. Morag Scordilis
61. Latifah Shakir
62. Denise M. Sheridan
63. April Shipp
64. Carole Gary Staples
65. Roy Starke
66. Jenny Svensson
67. Felecia Tinker
68. Odette Tolksdorf
69. Elmine van der Walt
70. Bettie van Zyl
71. Diana Vandeyar
72. Hilda Vest
73. Hester Viles
74. Enid Viljoen
75. Sheila Walwyn
76. Janet Waring
77. Sherry Evon Whetstone
78. Valerie C. White
79. Leni Levenson Wiener
80. Sauda Zahra
81. Sabrina Zarco

In 2013 the world mourned the passing of Nelson Rolihlahla Mandela, one of its most revered champions of human rights. Mandela provided a moral compass for how we treat each other, how we lead our own lives, and how we need to continue to strive for a just, fair, non-racial, and democratic society. Artists around the world have long made quilts in tribute to Mandela and in support and advocacy for the principles to which he was devoted. But it was for South Africans and African Americans that making quilts in tribute to Mandela has had special meaning. This exhibition, featuring quilts made in 2013 and 2014, was developed by the Michigan State University Museum and the Women of Color Quilters Network in association with quilt artists across South Africa. These diverse and often powerful pieces reflect the ways in which this remarkable man touched individual lives, changed a nation, and literally served as the conscience of the human spirit for individuals around the world.

— **Marsha MacDowell, Ph.D., Professor and Curator, Michigan State University Museum and Director, The Quilt Index (www.quiltindex.org)**

— **Carolyn L. Mazloomi, Ph.D., Independent Scholar and Founding Director, Women of Color Quilters Network**

PIECES OF AFRICA

The concept of beauty is interpreted differently by different peoples, cultures and nations. Stated in another way, there are many ways of characterizing someone or something as being beautiful. In pre-colonial African societies, women and men painted their bodies with ochre, and some sported permanent tattoos. They aimed to beautify themselves and to look unique with attractive artistic work in the eyes of the beholder.

The introduction of new technologies and materials into African societies fostered new expressions of personal adornment and notions of beauty. Certain types of fashion became dominant in certain regions, and specific variations became signifiers of ethnic identities. During the apartheid era, clothing and personal adornment that signified those identities also became symbols of resistance. For instance, in 1961 when Nelson Mandela stood trial for leaving the country without valid travel documents, he attended some of the court proceedings wearing the traditional beadwork and clothing of his abaThembu (Xhosa-speaking) culture. This was a direct challenge to the South African courts that were steeped in Western culture. Who can forget the images of Winnie Mandela, Albertina Sisulu, and other wives of Rivonia trialists, wearing their African attire during the trial?

Textiles were not only traditionally used to make clothing, they were also used to make blankets needed as bedcoverings or worn over clothes to keep warm. When individuals did not have enough money to buy a blanket, they would sew together pieces of cloth into a large warm blanket. These patchwork blankets were both statements of fashion and items of necessity.

It is especially fitting, then, that this exhibition features fabric art to pay tribute to Nelson Rolihlahla Mandela, a member of the Madiba clan and an African, a South African, who because of his deep belief in non-racialism, non-sexism, and democracy became an internationally-acclaimed fighter for human rights. Many artists around the world have honored and memorialized Mandela in their work. This exhibition expands that body of artistic work and helps us remember the life and legacy of our great leader. Surely these fabrics with different Mandela designs will contribute to our knowledge and understanding of how the world sees Nelson Mandela.

— **Pumeza Mandela, Education, Outreach and Material Development Manager, Nelson Mandela Museum**
— **Noel Solani, Ph.D., Heritage Conservation Senior Manager, Nelson Mandela Museum**

QUILTED TOMES:
MANDELA STORIES IN CLOTH

In his autobiography, *Dreams from My Father,* and in several speeches, Barack Obama has tethered his own political awakening to the anti-apartheid movement and his admiration for Nelson Mandela, who was incarcerated on Robben Island during Obama's undergraduate years and was released from prison while the future United States president was studying at Harvard Law School. Just as President Obama can reflect on key moments in his adult life when the political struggles of Mandela and his beloved homeland captured his heart and mind, so too can the artists represented in this exhibition recall their own encounters with South African culture.

For the South African quilters, the circumstances surrounding the life of Nelson Mandela are their own. The trajectories of their lives are tightly woven with those of the man so many of them can call "Madiba." If they were alive when he was in prison, they too were ensnared in an intractable caste system in these days before democracy. When he was free and a constitution based on human equality was established, their liberation was also at hand.

For the African American quilters, the life and times of Nelson Mandela were not often an unyielding thread in their experiences. American politics and its struggles took precedence but many were keenly aware of the fights for freedom being waged on other shores. American artists older than President Obama may recall when the African National Congress (ANC) freedom

fighter was first sentenced in 1964. Many quilters in this exhibit are closer in age to Obama and, like him, they can reflect on college years during which the anti-apartheid struggle was a defining component of their political awakening. For younger quilters the release of Mandela from prison may be etched in their minds, the famous image of the gray-haired man in the dignified suit walking with his then wife with their fists clenched and raised in the air. For even younger quilters, Nelson Mandela may have always been an avuncular elder statesman, garbed in a colorful shirt. Understanding his significance requires a history lesson, an intrinsically compelling history lesson, but a narrative in the past tense.

History lessons underscored the first known American quilts to celebrate heroes. Created in the early 1950s to stimulate audiences to learn more about their subjects, an integrated quilt guild commemorated the ex-slave abolitionists Frederick Douglass and Harriet Tubman who were then absent from the history books. While Nelson Mandela will never be absent from history books, these quilts have the power to inspire their viewers to increase their understanding of the man, the world he came from and the world he helped to shape.

— **Patricia A. Turner, Ph.D., Vice-Provost, University of California-Los Angeles, California, USA and author of *Crafted Lives: Stories and Studies of African American Quilters***

"Understanding his significance requires a history lesson, an intrinsically compelling history lesson, but a narrative in the past tense."

[1] Roland L. Freeman, *A Communion of the Spirits: African-American Quilters, Preservers, and Their Stories.* Nashville: Rutledge Hill Press, 1996, pp. 145-46.

MANDELA:
HIS LIFE AND LEGACY IN THREAD

Around the world, textile forms reflect many influences and motivations, including differing and sometimes merging cultural traditions, strategies for economic development and women's empowerment, access to new technologies and materials, the access or denial (as in South Africa during the Apartheid era) to worldwide information, marketplaces, equipment, and materials, as mechanisms to convey memories, beliefs and ideas, and their use as tools for healing, wellbeing, education, activism, and social change.[2]

Textile artists worldwide have long used textiles "to prick the to the conscience" of others about injustices or issues that they felt needed to be addressed.[3] During the years that Nelson Mandela was imprisoned and there were international embargos on communications with South Africans, artists both in South Africa and around the world used their work to draw attention to the anti-apartheid activities for which Mandela and other activists strove.

When Nelson Mandela was released from prison, it was worldwide news. Artists celebrated and marked the occasion, some by making quilts.

[2] Two previously written articles inform this essay. The first "Textiles and Quiltmaking in a Rainbow Nation' was published in Spike Gillespie, ed. *Quilts Around the World* (Minneapolis, MN: Voyageur Press, 2010) pp. 294-299. The second, "Materializing Mandela's Legacy: Textiles of Activism, Honour, Celebration, and Memory" was an invited presentation at the 2008 colloquium Critical Reflections on the Legacy of Nelson Mandela: Tracing the making and meaning of liberation struggles in African museums and heritage" coordinated by the Nelson Mandela Museum and held at the University of Fort Hare, East London campus, September 24-27, 2008. An article version of the presentation is included in a forthcoming volume published by University of Ft. Hare Press. The author is currently working on a book-length manuscript on the history of South African quiltmaking.

[3] The oft-quoted phrase in the context of a society's morale stance stems from the writing of Angelina E. Grimke, who, along with her sister Sarah, was a staunch 19th century anti-slavery advocate. In her *Appeal to Christian Women of the South* (New York: American Anti-Slavery Society, 1836) she wrote "Even the children of the north are in scribing on their handy work, 'May the points of our needles prick the slaveholder's conscience.'" See full text of the appeal at http://utc.iath.virginia.edu/abolitn/abesaegat.html. Accessed October 1, 2013.

FIG. 1
Mr. Mandela
- Made in 1990 by Beverly White
- Pontiac, Michigan, USA
- Cotton, cotton/polyester blends, neck tie; machine pieced, hand appliquéd, embroidered, hand quilted
- Collection of Michigan State University Museum, 2003:50.2
- Image courtesy of the MSU Museum; photograph by Pearl Yee Wong
- Quilt Index http://www.quiltindex.org/basicdisplay.php?kid=1E-3D-1311

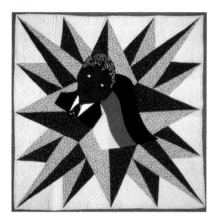

For instance, Beverly White, an African American woman from Pontiac, Michigan, USA says of her tribute, 'the inspiration for the *Mr. Mandela* quilt came from the very strong emotions of elation and relief I experienced when he was released from his years of captivity in South Africa'.[4] **[FIG. 1]** Hilda Vest, another African American woman who was a student at Michigan State University in the 1950s (an era when African Americans could not rent or own homes in the university town and when only one in a hundred students enrolled at the university were African American), also responded to the news of Mandela's release from prison by making a quilt. As Vest explains:

> Fascinated by African fabrics since discovering the joys of quilting, I was auditioning scraps of brilliant colors when news of Nelson Mandela's release from prison flooded the airwaves. How timely, I decided it would be, to fashion the King's X pattern I had already chosen into a humble "monument" dedicated to his survival after twenty-seven years as a political prisoner. African symbols where incorporated into the quilting and I proudly embroidered MANDELA FREED 2-11-90'.[5] **[FIG. 2]**

Another Detroiter, Carole Harris, was inspired to make a quilt she titled *Reclamation*. She says it was 'an expression of the feelings of pride that I and others felt upon seeing Mandela stride out of that prison gate, reclaiming his freedom, our history, ourselves'.[6]

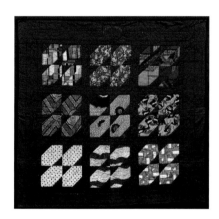

FIG. 2
Tribute to Nelson Mandela
- Made in 1989 by Hilda Vest
- Detroit, Michigan, USA
- Cotton; hand pieced; embroidered
- Image courtesy of the MSU Museum; photograph by Pearl Yee Wong
- Collection of the artist
- Quilt Index http://www.quiltindex.org/basicdisplay.php?kid=1E-3D-2259

[4] Beverly White, Michigan Quilt Project Inventory Form 93.119, Michigan State University Museum Research Collections. See also Marsha MacDowell, ed., *African American Quiltmaking in Michigan*. East Lansing: Michigan State University Press, p.30. NOTE: White donated the quilt to the Michigan State University Museum. Quilt image and data can be accessed at the Quilt Index, (www.quiltindex.org). See videotape interview with Beverly White, Quilts and Human Rights exhibition, http:www.youtube.com?v=4L7Eefjr2ts&feature=related [accessed September 8, 2008].

[5] Hilda Vest, Michigan Quilt Project Inventory Form, Michigan State University Museum Research Collections. See videotaped interview Hilda Vest, Quilts and Human Rights exhibition, http:www.youtube.com/watch?v=uhG3S0oeJRM (accessed September 8, 2008).

[6] Personal communication, 11 March 2009.

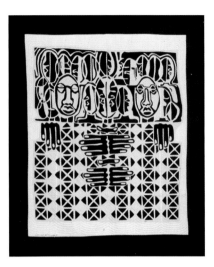

FIG. 3
The Embrace
• Made in 1995 by Carolyn L. Mazloomi
• West Chester, Ohio, USA
• Cotton fabrics and batting; hand reverse appliquéd and hand quilted
• Quilt given to Nelson Mandela; current whereabouts of quilt unknown

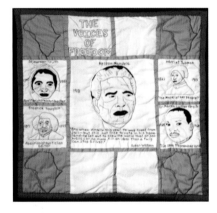

FIG. 4
Nelson Mandela
• Made in 2000 by Deonna Green
• Remus, Michigan, USA
• 24 ½ x 24 ½ inches
• Cotton fabric, polyester batting; hand
• embroidered, machine pieced, machine quilted
• Collection of Michigan State University Museum, 2000:67.3
• Image courtesy of the MSU Museum;
• photograph by Pearl Yee Wong
• Quilt Index http://www.quiltindex.org/ basicdisplay.php?kid=1E-3D-13E2

When, in 1990, Nelson and Winnie Mandela came to the USA for the first time in what was called the Freedom Tour, they were showered with gifts, including quilts, at each of the venues they visited. Dr. Carolyn L. Mazloomi, founder of the Women of Color Quilters Network, was one of the quilt artists who made a gift to Mandela of one of her most unique quilts.[7] **[FIG. 3]** Sadly the location of Mazloomi's quilt and the over 150 quilts known to have been made as formal presentations to Nelson Mandela, the man, or Nelson Mandela, the president, are unknown.[8]

Long after Mandela's release from prison and his USA Freedom Tour, he has continued to be a source of inspiration to textile artists in the US. For instance Sondra Hassan of Washington D.C., originally got the idea for a quilt when Mandela was released from prison, but made it years later as part of her South Africa Series, a "series [which] was born out of my hopes for equal rights in South Africa, for a country where black people could move about freely, without the necessity of a government-issued pass. It honors the black South Africans who struggled for their freedom".[9] In the small rural town of Remus, Michigan, Deonna Green, a fifth generation descendant of a former slave, created a quilt of the faces of men and women who she considers heroes; among these images is Mandela.[10] In 2000, Green also made a smaller quilt, this time with Mandela's face prominently embroidered in a central square. Underneath his face are these embroidered words, "Nelson Mandela 1918", and a quote from Susan Watson, an African American journalist, "and finally this year He was freed from jail – but still not free to vote in his homeland – he set out to show the world that prison walls

[7] Personal communication, August 2008
[8] According to Narissa Ramdhani, formerly Nelson Mandela's personal archivist, she and Irene Menel unpacked 150 quilts in the boxes of presents given to Mr. Mandela. The quilts included many made and presented by Native Americans and members of Canada's First Nations. Personal communication, 20 November, 2008.
[9] Sondra Hassan, blog, December 27, 2007 by Sondra Hassan http://sondrahassan.com (accessed September 8, 2008).
[10] Deonna Green, Michigan Quilt Project Inventory Form, Michigan State University Museum Research Collections. See videotaped interview Deonna Green, Quilts and Human Rights exhibition, http://www.youtube.com (accessed September 8, 2008). See also, The Quilt Index, http://www.quiltindex.org (accessed February 1, 2009).

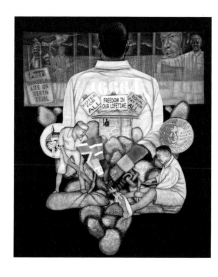

FIG. 5
Courageous
• Made in 2012 by Carolyn Crump
• Houston, Texas, USA
• Cotton; machine pieced, machine appliquéd, painted
• Collection of Michigan State University Museum, 2012:106.1; purchased with support from the MSU Foundation and Office for Vice President for Research and Graduate Studies
• Image courtesy of MSU Museum; photograph by Pearl Yee Wong
• Quilt Index http://www.quiltindex.org/fulldisplay. php?kid=1E-3D-2662

can no more kill an ideal than a twig can stop a river".[11] **[FIG. 4]** Today, more than twenty years later, Nelson Mandela's story is still an inspiration to artists, in America and around the world. **[FIG. 5]**

In South Africa, textile artists were also making quilts that memorialized the events of the struggle and paid tribute to the liberation leaders. For instance Susan Sittig of the Golden Rand Quilt Guild in Gauteng, worked with local beginner quilters outside of Johannesburg, South Africa, to make the *Sharpeville Massacre Quilt* to commemorate the horrific 1960 event, in which the police fired on a crowd of black protestors, killing sixty-nine.[12] South African textile artist Sandra Kriel used photo-transfer, piecing, and appliqué techniques to make a pictorial statement regarding the Cradock Four.[13]

Two extraordinary pictorial textiles titled *Journey to Freedom* were produced in 2004 especially for an event at the University of South Africa (UNISA) to mark the tenth anniversary of the new democratic South African government, and to reflect on the end of apartheid. Under the direction of Gwenneth Miller and Wendy Ross (UNISA, School of Arts), and professional artists Celia de Villiers, Sonja Barac and Erica Luttich, members of the Intuthuko Sewing Group and the Boitumelo Sewing Group created two embroidered memory quilts. Each square represents one woman's memories. The two panels include such historical events as the Sharpeville Massacre of 1960; the student uprising and massacre in Soweto in 1968; and the first elections under the new democratic government.[14] **[FIG. 6]**

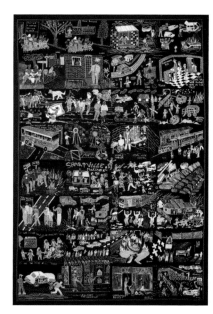

FIG. 6
Journey to Freedom
• Boitumelo Sewing Group
• Hillbrow, South Africa, 2004
• Hand-dyed cotton floss on cotton; hand tying, hand quilting
• Collection of University of South Africa
• Image courtesy of University of South Africa

[11] See The Quilt Index http://www.quiltindex.org/basicdisplay.php?pbd=MichiganMSUMuseuma0b9u0-a (accessed February 1, 2009). See also http://www.edjohnetta.com/ Ed Johnetta Miller is acknowledged as one of the most creative and colourful improvisational quilt-makers in the USA, her work has been widely exhibited in the U.S and abroad, and her quilts can be found in many important museums, corporate and private collections including The National Gallery of the Smithsonian Institution in Washington D.C.; Nelson Mandela's National Museum in Cape Town, South Africa; Wadsworth Athenaeum Museum of Art in Hartford, Connecticut; and the Rocky Mountain Quilt Museum in Golden, Colorado.
[12] Golden Rand Quilt Guild, South African Quilters Guild http://www.quiltsouthafrica.co.za/outreach.asp (accessed September 10, 2008).
[13] Personal observation of textile on view at the Mayibuye Center on May 24, 2002.
[14] Individual artists in the Intuthuko Sewing Group: Pinky Lubisi, Thembisile Mabizela, Zanele Mabuza, Angie Namaru, Lindo Mnguni, Julie Mokoena, Salaminha Motloung, Angeline Mucavele, Thabitha Nare, Nomsa Ndala, Maria Nkabinde, Cynthia Radebe, Sannah Sasebola, Rosinah Teffo, Lizzy Tsotetsi, and Dorothy Xaba. Individual artists in Boitumelo Sewing Group: Flora Raseala, D. Emmah Mphahlele, Lilian Mary Mawela, Ammellah M. Makhari, Martinah P. Mashabela, Naledzani R. Matshinge, Gloria /melula, Elisa D. Mahama, and Linda Mkhungo.

Roy Starke of Rietfontein, Gauteng, South Africa, created Madiba in 1997, stating that, 'this quilt was inspired by President Mandela of South Africa who spent the best years of his life as a political prisoner on Robben Island. The quilt was made as a gift for the president'.[15] In the early 2000s, Phina Nkosi and Vangile Zulu, textile artists who were members of the Zamani Quilting Sisters of Soweto, Gauteng, South Africa, made several versions of a quilt with fabric portraitures of black South African women activists and, in 2014, completed two versions of a quilt depicting the Rivonia Trialists. **[FIG. 7]** In 2004, South African textile artist Jenny Williamson showed her new 'Steps to Freedom' quilt at an exhibition of quilts in Port Elizabeth, Eastern Cape, South Africa. The quilt is simply a series of blocks of a shirt design rendered in different African prints, but the Presidential Shirt is now so firmly connected to Mandela that any South African viewer of the quilt, and many from around the world, will easily recognise that the design stands for the man.[16] **[FIG. 8]** Sally Scott's *Surrender* quilt is a statement on the ability to forgive, a trait for which Mandela was respected around the world. **[FIG. 9A and 9B]**

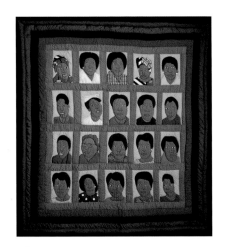

FIG. 7
*Black South African Women
Anti-Apartheid Activists*
• Made in 2004 by Phina Nkosi and
 Vangile Zulu
• Soweto, Gauteng, South Africa
• Cotton, cotton/polyester blend; machine
 pieced, machine appliquéd, beaded,
 hand quilted
• Collection of Michigan State University
 Museum, 2004:134.1; purchased with
 support from the MSU Foundation and Office
 for Vice President for Research and Graduate
 Studies
• Image courtesy of the MSU Museum;
 photograph by Pearl Yee Wong
• Quilt Index
 http://www.quiltindex.org/fulldisplay.
 php?kid=1E-3D-1DA4

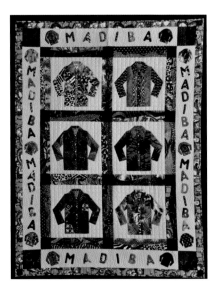

FIG. 8
Madiba Led the Way
• Made in 2012 by Pat Parker and
 Jenny Williamson,
• Johannesburg, Gauteng, South Africa
• Cotton; machine pieced, hand appliquéd,
 beaded, hand quilted
• Collection of Michigan State University
 Museum, 2012:127.1; purchased with support
 from the MSU Foundation and Office for Vice
 President for Research and Graduate Studies
• Image courtesy of the MSU Museum;
 photograph by Pearl Yee Wong
• Quilt Index
 http://www.quiltindex.org/fulldisplay.
 php?kid=1E-3D-26A4

[15] Norma Slabber, *A Passion for Quiltmaking: Leading South Africa Quilters Show and Tell,* Pretoria: J. P. Van der Waly, 1998, p. 16.
[16] Jenny Williamson and Pat Parker. Quilt Africa. Highlands North, South Africa: Wild Dog Press, 2004, pp. 79-82.

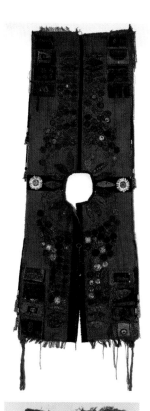

The quilts referenced above are but a small sampling of the ways in which Mandela's actions, values, character, and physical presence have been honored. The body of textiles that materializes Mandela's life story is as varied as the group of the makers of the work. Some are very explicit in their visual narrative or in the text that is written, embroidered, and painted on them. Others give very few, if any, visual clues that they are connected to Mandela's story or South Africa; yet it is in the artists' stories of why they were made and how they were used that we learn of their deep connections to South African history, to their own personal stories, and to Nelson Mandela.

— **Marsha MacDowell, Ph.D. Professor and Curator, Michigan State University Museum**

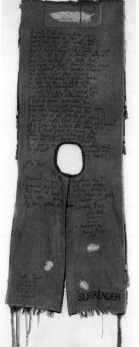

FIG. 9A and 9B
Surrender
• Sally Scott
• Grahamstown, Eastern Cape, South Africa
• Photograph courtesy of the artist
• *'Surrender'* symbolizes the process of forgiveness. It represents a conscious decision to lay down ones arms and give up the fight. It is about facing the wounds and letting them go. True freedom comes when we step out of the battle and start making choices that will lead us to a happier and healthier life.

The work is a battle jacket that normally hangs suspended like a 'skin'. The front of the piece has gaps and vulnerable areas. Our protective coverings are nothing but a flimsy illusion, as real protection comes from within, from having a strong heart and a self esteem that says, 'I'm OK, I feel good and I can hold my center irrespective of what comes my way.' The back has an ode about love written in 6BC by Anacreon; a poem that helped me to better understand 'forgiveness'.

When I think of Mandela, it was his ability to forgive that was his most remarkable attribute.

WOMEN OF COLOR QUILTERS NETWORK:
OUR TRIBUTES TO NELSON MANDELA

Throughout America there are families that have held on to quilts for generations and cherished them not for their function, but for the memories they embody.[17] I vividly remember sleeping under quilts that weighed so much, I could hardly move beneath them. Warm and snug, I could look at the patches and associate each one with a family member, living or deceased. There was a patch from Aunt Flo's church dress, and looking at it brought back the sight of her all dressed up in her Sunday best. There were pieces of my mother's crisp green satin party dress and my uncle's red plaid hunting shirt, soft from wear. The patches of the quilt were our genealogy, the link between generations of our family. They were the tangible reminders of our family's stories, rituals, and celebrations.

The Women of Color Quilter's Network (WCQN) came into being in 1986 when I, as an African American woman, made a commitment to preserve quiltmaking in the African American community.[18] My employment as an aeronautics engineer required that I travel throughout the county, and I always sought out quilt exhibitions. After attending countless exhibitions, I began to feel isolated. I never found work that I could identify as my own experience, and I never saw other African Americans in attendance. I placed an ad in a nationally circulated magazine asking African American quiltmakers to write to me. Nine women warmly answered the ad. As we communicated, I realized that in addition to sharing the same heritage, we all shared the same sense of isolation from the mainstream quilt community. Each woman also believed quilting was a dying art form within the African American community. Some were members of quilt guilds, but each was the only African American in her guild.

[17] Portions of this essay were previously published in the overall and chapter introductions in Carolyn L. Mazloomi, *Spirit of the Cloth: Contemporary African American Quilts,* New York: Clarkson Potter Publishers, 1998 and in Carolyn L. Mazloomi, *Journey of Hope: Quilts Inspired by President Barack Obama.* Minneapolis, MN: Voyageur Press, 2010.

[18] For more about the origins and activities of the Women of Color Quilter's Network, see Sandra K. German, "Surfacing: The Inevitable Rise of the Women of Color Quilters' Network," in Laurel Horton, ed., *Uncoverings 1993: Research Papers of the American Quilt Study Group, Volume 14,* pp. 137-168.

What they created was not always well received by their fellow guild members, who could not understand what these quilts were all about. African American quilters clearly needed acceptance and affirmation to sustain their creativity. They found it in "the Network" which became a home where there was freedom to work in all styles and techniques, whatever the skill level.

Like wildfire, news of the WCQN spread and within ten years the membership grew to more than 1500 enthusiasts and today the organization boasts 1700 members.

Despite its name and its focus on African American women, its membership is neither all women nor all quiltmakers of color; no one is excluded. Since its inception, the network has been a force in connecting African American quilt artists, conducting professional development workshops for artists, offering quilt lessons and educational programs for youth, and developing exhibitions of work that have been presented in many museums and quilt festivals in the United States as well as some in other countries. As a result of this collected, concerted work, there now is solid appreciation for the rich and diverse legacy of African American quiltmaking and of the work of contemporary African American quiltmakers.

The United States was born in conflict. There was the unparalleled slaughter of indigenous peoples; the strife that tore the colonies from England, their home base; and the largest forced migration in the history of mankind, which brought millions of Africans to the New World over a 200-year period. Our own history of resistance has been continuous, from mutinies by Africans on slave ships, to slave insurrections throughout the colonies, in the abolition, suffrage, and anti-lynching movements, and most dramatically, to the civil rights movement of the turbulent 1960s. Because of the conditions created by slavery, racism, and Jim Crow, protest has been a defining characteristic of our literature, art, and music. Among African American women, this resistance to oppression has been manifest in our activism and our creative expression.

Ancestor worship and respect for elders characterize the African cultural heritage that blacks brought with them into the New World. In a society that has not valued our humanity or recognized our accomplishments, it has been imperative that African Americans find ways to affirm their worth in a hostile land. And so "praise songs" for our heroes and heroines have played an important role in our culture and appear, as well, as themes in our quilts. American activists such as Harriet Tubman, Marcus Garvey, and Martin Luther King, Jr. are remembered, as are artists and musicians. There are praise songs for particular family members, friendships are honored, historic events celebrated, and cultural icons are memorialized. Praise songs enable us to affirm African American life, to counter stereotypes, and to restore our self-esteem as a people.

Quilts, in particular, have provided African American women with a mechanism to share memories, tell stories, and serve as outlets for social and political concerns since the colonial era; they have been used as weapons against a range of societal injustices. Dr. Johnnetta Betsch Cole states:

> African American women are often memory keepers and dream catchers. We are storytellers for our children, our people, and ourselves and it so often falls to us to catch and propel forward the grandest as well as the most precious of dreams. True to the art form that is so closely associated with women, these quilts make so much out of nothing, something African American women often do as we defy what is said to be impossible and manage somehow to "make do when don'ts wants to prevail.[19]

It is in the context of this history of resistance, ancestor worship, and respect for elders by African Americans that members of the Women of Color Quilter's Network have been active in making quilts that chronicle past and current injustices and pay tribute to those who made a difference. **[FIG 1]** In 2008, hundreds of artists, including many WCQN members, made scores of quilts in celebration of the election of Barack Obama as president of the

FIG. 1
Southern Shame
- Made in 2001 by Gwendolyn A. Magee,
- Jackson, Mississippi, USA
- Cotton, organza; machine pieced, appliquéd, and quilted
- Collection of Michigan State University Museum, 2008:159.1; purchased with support from the MSU Foundation and Office for Vice President for Research and Graduate Studies
- Image courtesy of MSU Museum; photograph by Pearl Yee Wong
- Quilt Index
 http://www.quiltindex.org/basicdisplay.php?kid=1E-3D-2550

[19] Carolyn L. Mazloomi, *Quilting African American Women's History: Our Challenges, Creativity, and Champions.* West Chester, Ohio: Paper Moon Publishing, 2008, p. 3.

United States. Quilt artists crafted for the world a stream of prayer cloths—quilts with the expressive, effective power of any fervent prayer. **[FIG 2]** Visible through these quilts were prayers of healing, deliverance, hope, and protection. Although quilt artists created work inspired by their own unique experiences, there were three recurring themes in many of the works: participation in the voting process, hope for a brighter future, and paying homage to freedom fighters in the fight for equality.

For decades, the Women of Color Quilters Network has wanted to participate in an exhibition of quilts in South Africa, as well as travel to the country. Since the early 1980s, when renowned quilt scholar, Cuesta Benberry, introduced me to the work of the Zamani Soweto Sister Council, I have admired their quilts.[20] **[FIG. 3]** In 1986, several members of the Sisters Council were brought to England as part of an economic development project. Cuesta was invited to England to teach quiltmaking to the women. After returning to the United States, Benberry shared with me a photograph of her latest quilt acquisition — a beautiful work by Maria Hlomuka.[21] **[FIG. 4]** Benberry wrote:

> I had written and become friends with Zamani prior to my meeting with them in London in 1986. I especially admired Maria Hlomuka because she was a poet as well as a creative quiltmaker. In London, I spent the most enjoyable three weeks with Zamani that I can remember. I bought the "Intombi Quilt" not only for its beauty but also to have a Maria Hlomuka work, a Zamani work, something unlike any other piece in the world.[22]

As Benberry traveled throughout the United States lecturing on the quilts of the Sisters Council and the plight of their members in South Africa, the Women of Color Quilters Network members were in attendance. Our entire network was mesmerized, not only by the beauty of the quilts made by the Sisters Council, but also felt a kindred and spiritual connection because both shared common ground in the political struggle for racial equality.

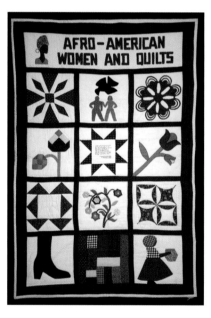

FIG. 3
Afro-American Women and Quilts
• Made in 1979 by Cuesta Benberry
• St. Louis, Missouri, USA
• Cotton; machine pieced, hand appliquéd, reverse appliquéd, embroidered, hand quilted
• Collection of Michigan State University Museum, Cuesta Benberry Quilt History Collection 2008:119.1
• Image courtesy of MSU Museum; photograph by Pearl Yee Wong
• Quilt Index http://www.quiltindex.org/basicdisplay.php?kid=1E-3D-2347

FIG. 2
In His Father's Village
• Made in 2009 by Valerie C. White
• Denver, Colorado, USA
• Collection of Carolyn L. Mazloomi, promised gift to Michigan State University Museum
• Image courtesy of Women of Color Quilters Network, photograph by Charles E. and Mary Martin

[20] The quilt history collections of Cuesta Benberry are now at Michigan State University Museum, donated to the museum by her son.
[21] Letters written by Cuesta Benberry to Carolyn L. Mazloomi, 1986- 94. Maria Hlomuka's quilt is now in the collection of the Michigan State University Museum. It was donated to the museum by Benberry's son.
[22] Mary Worrall, *Unpacking Collections: The Legacy of Cuesta Benberry, An African American Quilt Scholar*, The Cuesta Benberry Quilt and Ephemera Collection, Exhibition. Michigan State University, East Lansing, Michigan http://www.museum.msu.edu/glqc/collections_2008.119.07.html.

FIG. 4
Intombi
• Made in 1986 by Maria Hlomuka
• Soweto, South Africa
• Cotton; machine pieced and appliquéd, hand quilted
• Collection of Michigan State University Museum, Cuesta Benberry Quilt History
• Collection 2008:119.7
• Image courtesy of the MSU Museum; photograph by Pearl Yee Wong
• Quilt Index http://www.quiltindex.org/fulldisplay.php?kid=1E-3D-234D

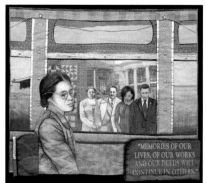

FIG. 5
The Bus That Paved the Way
• Made in 2011 by Carolyn Crump
• Houston, Texas, USA
• Collection of Michigan State University Museum, 2012.106.2; purchased with support from the MSU Foundation and Office for Vice President for Research and Graduate Studies
• Image courtesy of the MSU Museum; photograph by Pearl Yee Wong
• Quilt Index http://www.quiltindex.org/basicdisplay.php?kid=1E-3D-2663

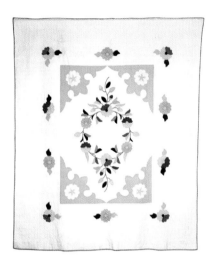

FIG. 6
Appliquéd Floral Medallian
• Made in 1939 by Rosa Parks
• Detroit, Michigan, USA
• Cotton; hand appliquéd and quilted
• Collection location currently unknown
• Image courtesy of the MSU Museum; photograph by Pat Power
• Quilt Index http://www.quiltindex.org/basicdisplay.php?kid=1E-3D-1309

Although on different continents, such was the special relationship between African Americans and black South Africans. Our fight for civil rights and the anti-apartheid movement shared a history for democratic change. As a young girl growing up in segregated Louisiana and Mississippi, I know from personal experience what it is like to live under white dominion without civil rights. I had a "front row seat" to demonstrations, protest marches, and boycotts against segregation while living in the deep South. I vividly recall hearing news of Rosa Parks's brave stand against segregation. Carolyn Crump's quilt, Courageous, depicts the courage of Parks, one such "soldier of the cause". **[FIG. 5]** On December 1, 1955, in a lonely act of defiance, Parks refused to give up her seat on the bus to a white man. Many historians date the act as the catalyst for the modern Civil Rights Movement in the United States. It is interesting that Rosa Parks was a seamstress, who also made quilts.[23] **[FIG. 6]**

Nelson Mandela and Dr. Martin Luther King Jr. never met, but each fought for the same cause at the same time on two different continents. King appreciated and supported freedom for South Africa's black citizens and Mandela, even in prison, was aware of the work of King and other U.S. champions for civil rights. Both men dreamed of a society where blacks and whites were equal. The influence and admiration went both ways: the anti-apartheid struggle inspired civil rights activists in America, and freedom fighters in South Africa were inspired by civil rights activities by blacks in America. In his own autobiography, Long Walk to Freedom, written partially during the 27 years he was jailed in South Africa, Mandela recounted a speech he gave about the close connection between the two countries: "I spoke to a great crowd at Yankee Stadium, telling them that an unbreakable umbilical cord connected black South Africans and black Americans, for we were together children of Africa. There was a kinship between the two...In prison, I followed the struggle of black Americans against racism, discrimination, and economic inequality."[24]

[23] Carolyn L. Mazloomi, *Threads of Faith: Recent Works by the Women of Color Quilters Network*. New York: Museum of Biblical Art, 2004, p. 98.
[24] *Nelson Mandela, Long Walk to Freedom, New York: Little Brown & Company, 1995, p. 364.*

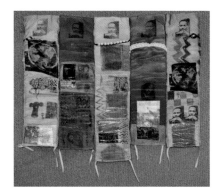

FIG. 7
From a Birmingham Jail: MLK
• Made in 1996 by L'Merchie Frazier
• Roxbury, Massachusetts, USA
• Image courtesy of Carolyn L. Mazloomi;
 photograph by L'Merchie Frazier

Depicted in the quilt are images of the March on Washington for jobs and freedom, where King delivered his famous "I Have a Dream" speech. The quilt utilizes the traditional format of African strip cloth production that honors and deifies ancestors and high cultural figures. For interaction with the viewer, a pocket holds quilted news articles, including an account of the 1964 award of the Nobel Peace Prize to King.

Both Mandela and King were inspirational speakers. In December 1965, King delivered a speech in New York City in which he denounced the white rulers of South Africa as "spectacular savages and brutes" and called on the U.S. and Europe to boycott the nation, an approach that the West ultimately embraced and that helped end white rule.[25] In 1957, a letter written by King while jailed in Birmingham, Alabama, was a powerful call for civil rights. Still often quoted, it has served as an inspiration for social justice activists and artists. **[FIG. 7]**

Nelson Mandela was a man who believed in forgiveness, and he encouraged both whites and blacks to forgive one another. The story of Adriaan Vlok, former Minister of Law and Order in South Africa during the late 1980s, inspired me to make a quilt. He instigated violence and caused the death of hundreds of blacks. Vlok came forward after he was offered amnesty through the Truth and Reconciliation Commission.[26] He offered to wash the feet of mothers whose sons were killed during his term in office. I feel the most humble thing one human being can do for another is to wash their feet. **[FIG. 8]**

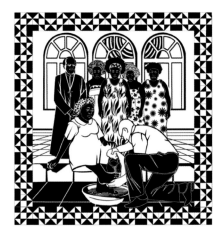

FIG. 8
In the Spirit of Forgiveness
• Made in 2014 by Carolyn L. Mazloomi
 West Chester, Ohio, USA
• Promised gift to Michigan State
 University Museum
• Image courtesy of Women of Color Quilters
 Network, photograph by Carolyn L. Mazloomi.

[25] Nelson Mandela, Human Rights Day speech, Hunter College, New York, December 10, 1965.
[26] Ian MacDonald, "Many Feet to Wash", *South Africa: The Good News,* September 8, 2006, p.12.

Members of Women of Color Quilters Network and friends cherish the legacy of Nelson Mandela, and are inspired by his courageous struggle, dedication and conviction to bring equality and self-determination to the black citizens of South Africa. The engagement of members of the Women of Color Quilter's Network in making quilts to honor the legacy of one of the world's most honored fighter for human rights – Nelson R. Mandela – continues their traditions of chronicling injustice and respecting those who made a difference. And, in joining with South African quiltmakers in this special endeavor, they build bridges across time, space, and cultures.

— **Carolyn L. Mazloomi, Ph.D., Founding Director, Women of Color Quilters Network**

IS SLEEPIN

out like the s

you'll alw

QUILT TRIBUTES TO
NELSON R. MANDELA
NOTE: Unless otherwise indicated, each quilt is owned by the artist who made it

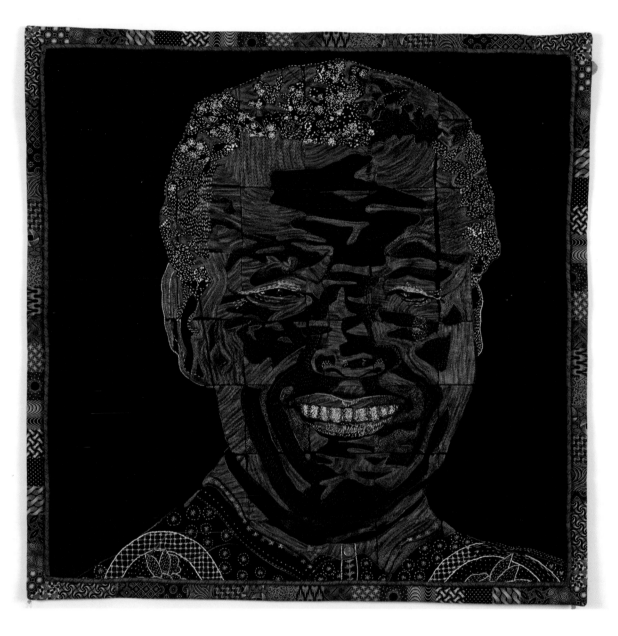

1. INTUTHUKO EMBROIDERY GROUP ARTISTS WITH HESTER VILES
Catalyst for Change
Etwatwa and Johannesburg, Gauteng, South Africa | Hand dyed threads on 100% South African cotton fabric and edged with traditional Shweshwe fabric; embroidered, pieced

Artists who have had the privilege to study art on a formal level can work with informal artists to empower them to take social, ecological, and economic control of their environment. Such collaboration activates strategies that extend beyond visual narratives and aesthetic pleasure and is instrumental in generating a sense of achievement and a shared belonging and trust in the community.

Twenty-three informally trained women artists of the Intuthuko Embroiderers created the individual embroidered pieces; artist Hester Viles combined the pieces into a complete quilt. The value of this embroidery project is found in its inclusiveness that creates a dialogue and echoes the co-operative spirit between Nelson Mandela and Willem de Klerk. This is an expression of the traditional meaning of ubuntu, an African word that transcends any written definition and is best expressed as "I am a person because of other people". The collaboration between these two leaders is regarded all over the world as a catalyst for dramatic social and political change in South Africa and is echoed by the interchange between these artists from diverse backgrounds.

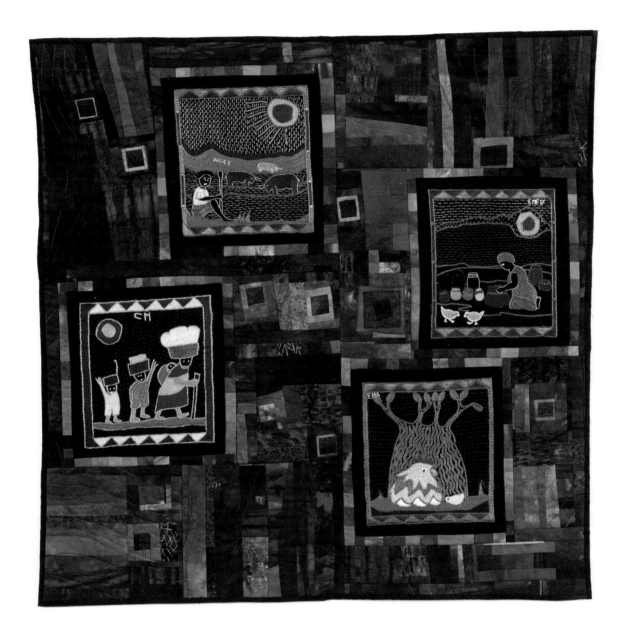

2. TAMBANI PROJECT ARTISTS WITH JENNY HEARN
The Mandela Story
Venda, Limpopo, and Johannesburg, Gauteng, South Africa | Hand-dyed cotton, commercial cottons, polyester batting; machine pieced and quilted

In the very north of South Africa, between the Zoutpansberg Mountains and Zimbabwe is a region of harsh, dry climate where only thorn and baobab trees flourish. It is here in this uncompromising environment that Venda peoples scratch a meager subsistence from planted mielies (corn), sweet potatoes, and chilies and by keeping a few goats and chickens. The oral traditions of the Venda are rich and some women, through a project initiated by Venda scholar Ina le Roux, are now rendering their stories in embroidered cloths that are sold to supplement their income. Cloths are sold singly or pieced together, as in this one, to form a wall hanging or quilt. Quilt artist Jenny Hearn pieced together this set.

The first cloth here depicts Nelson Mandela in his youth as a cattle herder. The next shows the simple rural life of Venda where women make pots with river clay; these pots may be interpreted as vessels of hope for a better future. The third shows 1994, the end of apartheid and people going off to vote. The fourth picture is of Mandela, the protector of his people, sitting under the baobab.

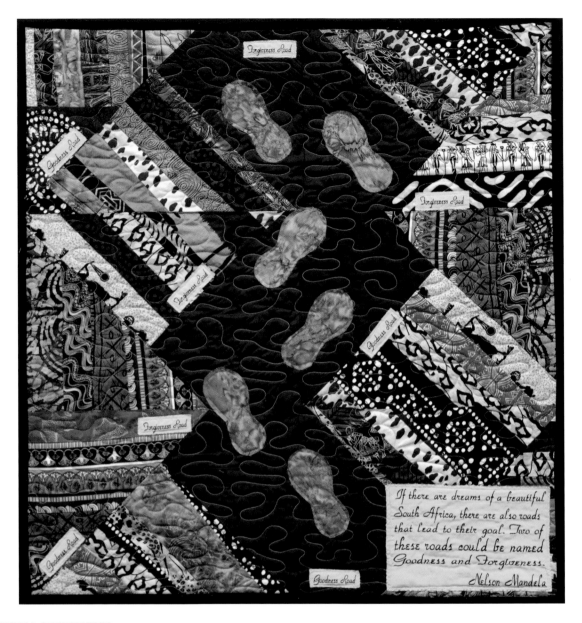

3. REGINA ABERNATHY
Mandela — Forgiveness and Goodness Road
Shaker Heights, Ohio, USA | African fabric, fabric with African designs, cotton, and batik; pieced, appliquéd, and quilted

If there are dreams of a beautiful South Africa, there are also roads that lead to their goal. Two of these roads could be named Goodness and Forgiveness. — Nelson Mandela

I enjoy using a variety of fabrics with diverse colors, motifs, textures, and symbols to reflect the complexity of the people, their joy and pain, struggles and triumphs of life, and the long and complicated history of the continent. Thus the fabric helps to illustrate and complete the story told by the quilt.

For this quilt, I placed the fabrics in rows or columns to represent the many roads that Nelson Mandela had to travel and to denote an incompleteness of journeys. Mandela's life journey encompassed so many emotional highs and lows, so many twists and turns, and so many defeats and triumphs. Nelson Mandela was graced with the wisdom to understand that in order for South Africa to become a truly democratic and prosperous country for all people, there are additional roads that must be travelled by all South Africans. He knew those roads would be long, winding, and extremely difficult. Nevertheless those journeys can be accomplished and the largest road must be travelled with God's guiding hand.

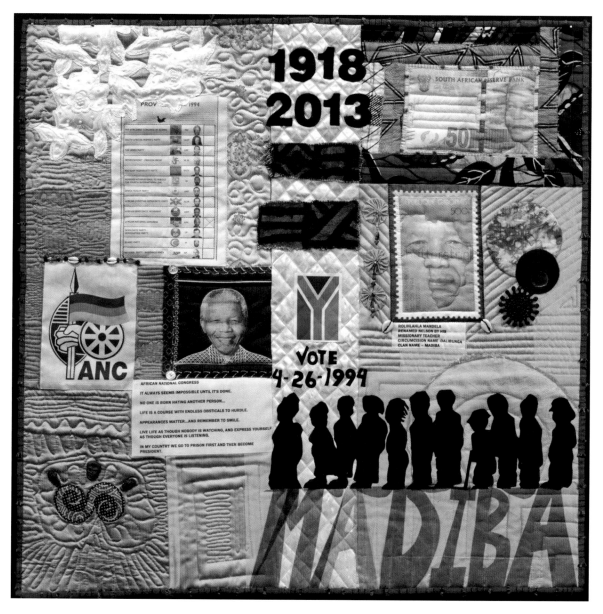

4. ALLYSON E. D. ALLEN
Madiba
Sun City, California, USA | Cotton, silk, velvet, hand dyed cotton, African prints, mud cloth, felt, tulle, and African indigo with yo-yos, glass, pearls, and wooden beads, cowrie shells, dried seeds, African cutwork lace, mirror, handmade clay face and hands, and photo transfer embellishments; machine pieced, machine and hand appliquéd, embroidered

Madiba, Nelson Mandela's clan name, and Dalibunga, Mandela's circumcision name, are often heard in songs and stories about the South Africa leader. This quilt features several important events in South African history and in the life of Mandela, including voters standing in long lines for the April 1994 presidential election and one of the election ballots. With additional images of a South African postage stamp and a rand, this is a visual and tactile document of Mandela history.

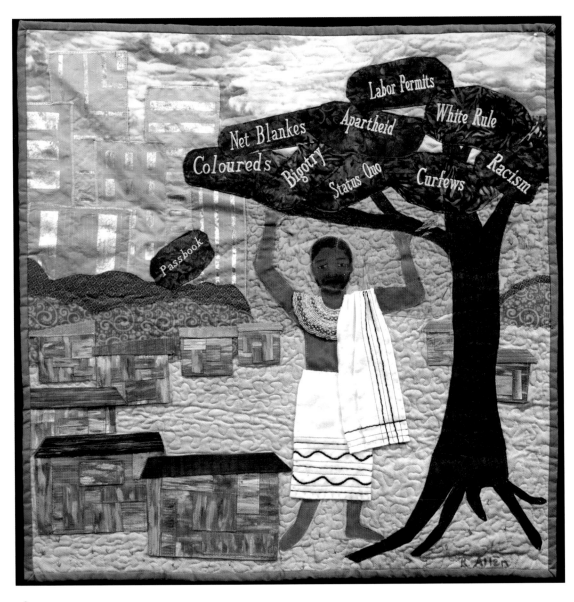

5. RENEÉ M. ALLEN
Rolihlahla
Ellenwood, Georgia, USA | Cotton, paint, beads, felt; machine appliquéd and quilted, hand beaded, embroidered

Rohilhlahla, in Xhosa meaning "pulling of the branch of the tree" or "troublemaker", is the birth name given to Nelson Mandela by his father. As was tradition at the time that Nelson Mandela went to school, his teacher gave him an English name that was easier for the teacher to pronounce. His Xhosa name, however, prophetically told of his role in changing South Africa.

I have depicted Nelson Mandela here dressed in his Xhosa traditional clothing. He is pulling the branch of a tree representing institutional racial segregation. He shook the tree and dismantled the apartheid system in South Africa. Mandela also created the Truth and Reconciliation Commission to heal the wounds of apartheid.

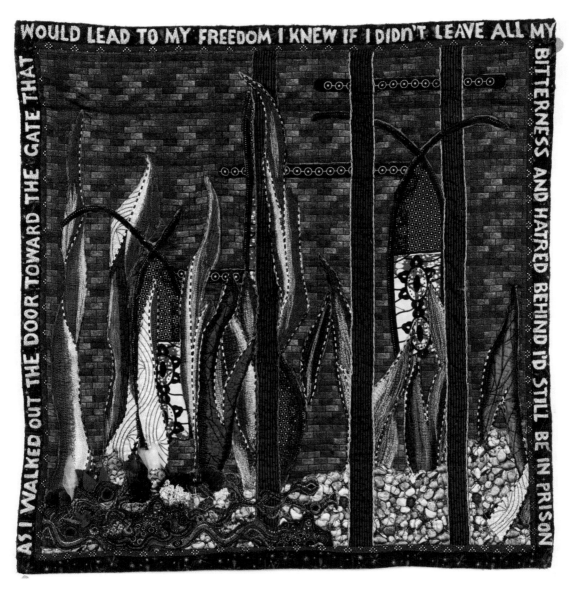

Text visible in the quilt artwork:
WOULD LEAD TO MY FREEDOM I KNEW IF I DIDN'T LEAVE ALL MY
AS I WALKED OUT THE DOOR TOWARD THE GATE THAT
BITTERNESS AND HATRED BEHIND I'D STILL BE IN PRISON

6. KARIN ARBETER
Madiba's Freedom
Johannesburg, Gauteng, South Africa | Cotton fabrics, cotton thread, Shweshwe, felt; hand and machine quilted, felted

As I walked out the door towards the gate that would lead to my freedom I knew if I didn't leave my bitterness and hatred behind, I'd still be in prison. — Nelson Mandela

This work depicts the almost surreal life of South Africa's most coveted statesman who fought for and won freedom for all South Africans. During the years of the struggle against apartheid, Madiba was captured and sentenced to life imprisonment where he was subjected to degradation. He moved from freedom to imprisonment, then back from imprisonment to freedom; from breaking stones, as a prisoner, to becoming the respected leader of our beloved country. His ability to forgive and love is legendary.

The left side of this quilt depicts freedom: the right side imprisonment. The piece reflects Madiba's passion for the African prints that were used in the shirts that became his personal fashion statement. The variety of threads sewn over layered African prints reflects the uniqueness of Madiba. The felted fabric around the edge and collaged layers reflect the historical strata and complexity of South Africa during his remarkable life. The shapes of the prints are reminiscent of traditional African shields and assegais. The inclusion of Shweshwe material, produced in South Africa, reinforces the "African-ness" of the piece.

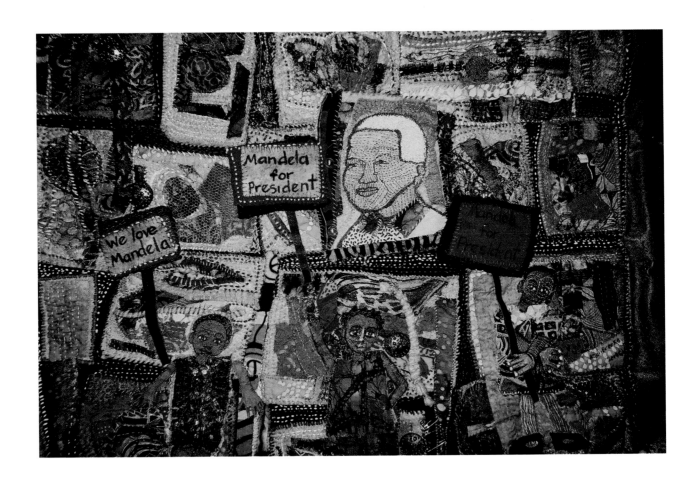

7. GWENDOLYN AQUI-BROOKS
Election Day, A Joyful Moment
Washington, District of Columbia, USA | Felt, buttons, beads, acrylic paint, ribbons, cotton and silk thread, yarn, floss, various types of fabric; all hand-sewn

I've attempted to depict the excitement of the day in Johannesburg, South Africa when Nelson Mandela became president. The colors of the quilt represent the following: blue – the beautiful sky above the city; orange – the hope for the future; and red – the strength exemplified by Mandela. The buttons represent the numerous people in the street; the squares represent the houses and shops.

My poem here further describes the quilt story:

This is no ordinary day in Johannesburg.
The sun shone bright,
Bright was the sun,
Table Mountain stood majestically,
Shops and major stores were closed for the day,
Large crowds of people marched with placard that said:
"We Love Mandela"
"Mandela for President"

Women's melodic voices could be heard singing.
What a lovely sound.
Little children were seen dancing, dancing, round and round.
Hands were clapping, clapping, clapping.
What a joyous day.
Nelson, Nelson,
Nelson Mandela had been elected President.

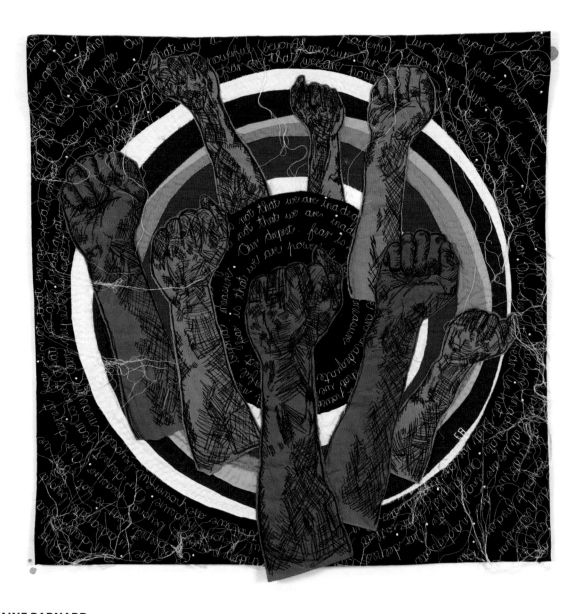

8. ELAINE BARNARD
Amandla!
Newcastle, KwaZulu-Natal, South Africa | Cotton and polyester fabric; appliqué, freestyle machine embroidered, hand quilted and tied

I grew up in South Africa under apartheid. We were never allowed to see any image of Mandela. The very first time I saw him, and I believe the rest of South Africa, was when he walked out of Victor Verster prison, raising his fist above his head. That fist was what I wanted to portray in my quilt – freedom! Amandla!

In this quilt I used the colors of our national flag to symbolize our rainbow nation after the release of Mandela. I also used the words Mandela quoted from Marianne Williamson in his inaugural address in 1994: "Our deepest fear is not that we are inadequate. Our deepest fear is that we are powerful beyond measure. It is our light not our darkness that most frightens us."

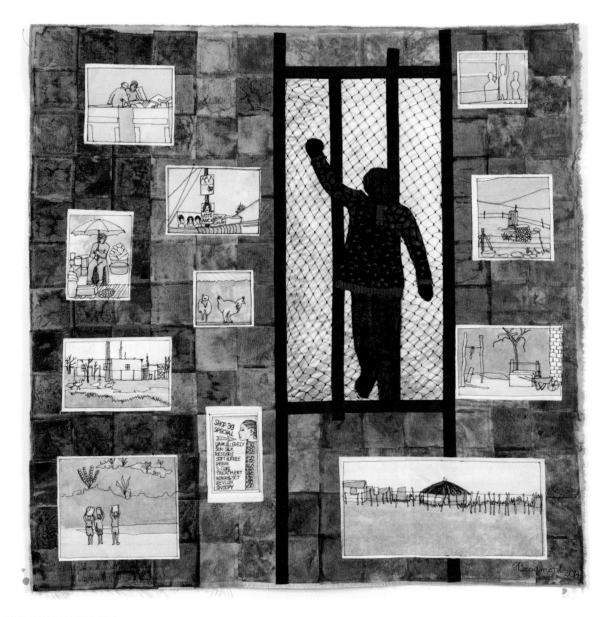

9. HELGA BEAUMONT
To Be Free
Kloof, KwaZulu-Natal, South Africa | Tea bags, photo transfers on Lutradur, silk paper, felt, heavy canvas, netting; embroidered, quilted

For to be free is not merely to cast off one's chains, but to live in a way that respects and enhances the freedom of others. – Nelson Mandela

With Nelson Mandela's release and the elections of 1994, a new regime in South Africa was born and with Nelson Mandela at the helm, we had peace and a new vision for a better South Africa – 'The Rainbow Nation' as Desmond Tutu described us. Now 20 years into democracy and with the elections of 2014 over, we are well and truly established onto a path of equality for all – a path that Madiba dreamt of and made possible for all South Africans.

This Madiba quilt project appealed to me on all levels. I have an extensive collection of photographs and wanted to use them in this quilt to tell of the injustice suffered by so many who were deprived of the beauty of their country. I used tea bags to give the feel and texture of the prison walls, and used black and white fabric and threads, to symbolise the struggle between black and white. Madiba is raising his fist just as he did on that day that he walked, hand in hand with his wife Winnie, to freedom.

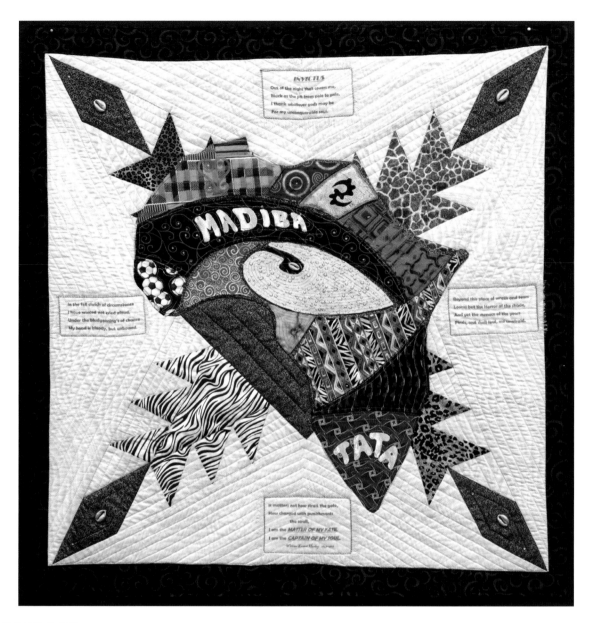

10. CAROL BECK
Madiba Remembered
Durham, North Carolina, USA | Cotton, silk organza, and metallic fabrics with Shweshwe "Madiba's Range" pattern cloth on the back, painted cowrie shells, hot-fix crystals, felt batting, computer printing on fabric; machine pieced and quilted

This is a fabric glimpse into the survival techniques and interests of Nelson Rolihlahla Mandela. The traditional Pine Burr quilt block pattern serves as the base background and symbolizes longevity and immortality. The stylized African continent overlay highlights several survival strategies during captivity and imprisonment, i.e. soccer, reading, and poetry. I used African Adinkra symbols to represent the love and deep respect so many had for Mandela as well as the words Madiba (Mandela's Xhosa clan name) and Tata (meaning Father and implying "Father of the Nation"). On the front of the quilt in the four rectangles are stanzas of the poem *Invictus* by William Ernest Henley.

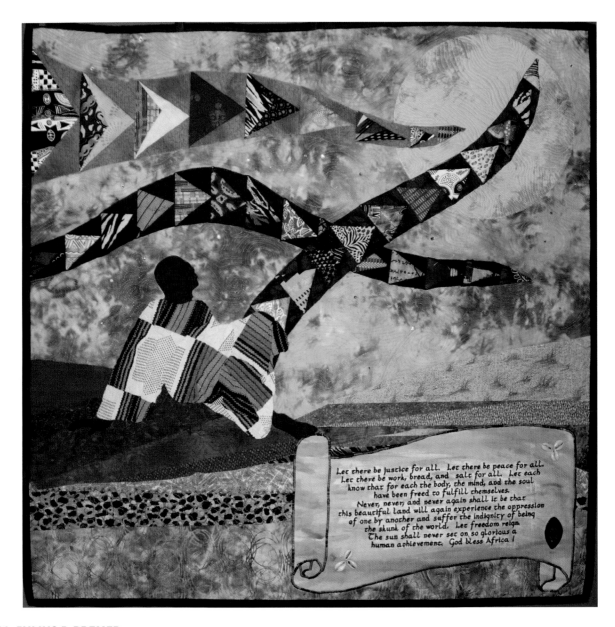

Let there be justice for all. Let there be peace for all.
Let there be work, bread, and salt for all. Let each
know that for each the body, the mind, and the soul
have been freed to fulfill themselves.
Never, never, and never again shall it be that
this beautiful land will again experience the oppression
of one by another and suffer the indignity of being
the skunk of the world. Let freedom reign.
The sun shall never set on so glorious a
human achievement. God bless Africa !

11. JULIUS J. BREMER
Madiba's World
Cleveland, Ohio, USA | Cotton, crystals, cowrie shells, glow in the dark thread; free motion quilted, fused and appliquéd pieced, embroidered

Nelson Mandela had a profound effect on both his country and the world. His suffering was not for selfish reasons, but for the love he had for humanity and Africa. It is inspiring how he used adversity and bigotry as catalysts to forge triumph for peace and equality.

In his presidential inaugural address, Mandela spoke of the things that all men desire, the God given rights to each and every one. As I created this quilt, I felt the love this man had for humanity and from that feeling I tried to incorporate, through the colors of the South African flag, the world of Madiba — the great and respected father of Africa.

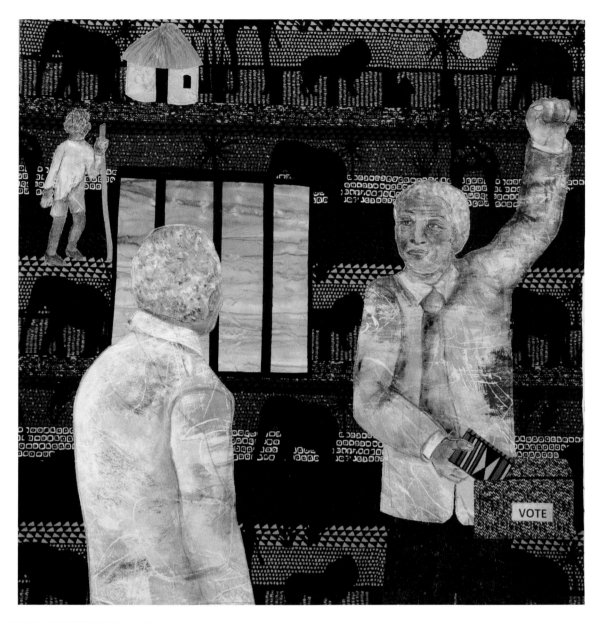

12. CAROLE RICHBURG BROWN
Nelson Mandela, Prince, Prisoner, President
Cleveland Heights, Ohio, USA; 2014 | Reclaimed fabric, colored pencils, upholstery fabric, fabric paint; appliquéd, pieced, free motion quilted

I recently ran across a quote by Edgar Degas, *"Art is not what you see, but what you make others see."* I think that this quote could be restated as *Art is not what you feel, but what you make others feel*. I would like for my quilts to evoke a feeling from the viewer.

The life of Nelson Mandela, who spent at least three quarters of his life struggling to abolish apartheid, was quite difficult for me to create as a quilt. Sadness permeated my heart each time I began to sketch him marching, in prison, voting, and pounding stone. I felt the sorrow of when he read of the infidelity of his wife, Winnie. I thought about the 27 years he spent in prison.

I chose colors, lines, and textures for my quilt that I hoped would communicate a vision, soul, rhythm, pathos, and mood with which the viewer could connect. I also hope the quilt evokes a feeling of celebration for Mandela's actions that abolished apartheid and for when he became president of South Africa.

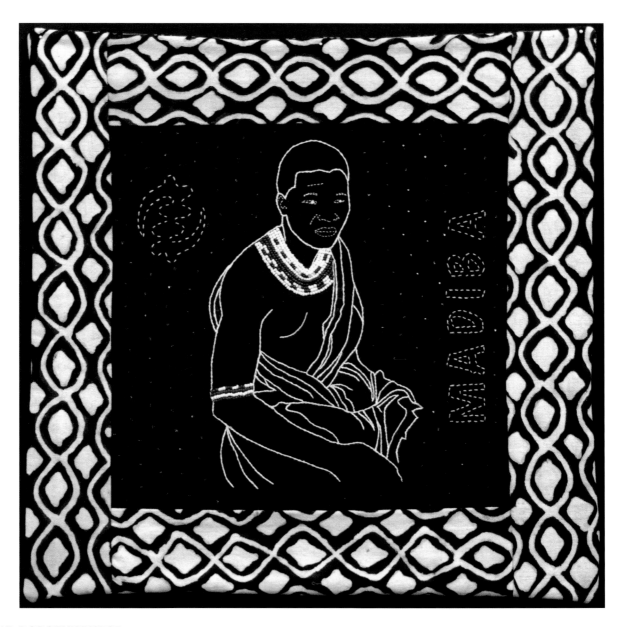

13. DOROTHY BURGE
Madiba
Chicago, Illinois, USA | Cotton and beads; machine pieced, hand embroidered and beaded

In 2012, I toured South Africa for the first time as part of a restorative justice delegation from Chicago. The time spent in the county was truly educational, inspiring and humbling. It was an amazing experience to spend time in a country that was experiencing so much hope for the future. It was also inspirational to see how public art was made to document historical events, honor its heroes, and teach about justice.

Throughout the country, the love for Mandela was evident. School children spoke of him with pride, love, and respect. Anti-apartheid activists throughout the country and from all walks of life recounted the wisdom learned from Mandela's life and his teachings. Mandela's life has been inspirational to all people who are fighting against oppression and people who believe in freedom and equality. I wanted to create something that would honor the life of Madiba and pay homage to the traditional South African art forms of hand embroidery, hand quilting and hand beading.

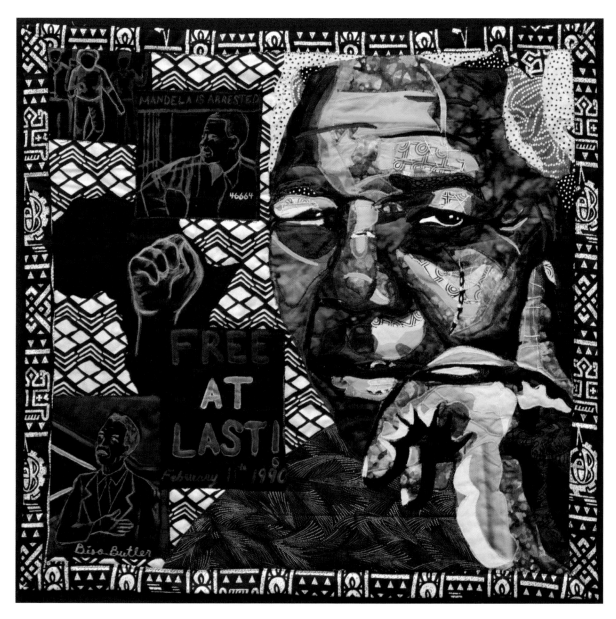

14. BISA BUTLER
Free At Last
West Orange, New Jersey, USA | Cotton, chiffon, netting, acrylic paint; machine quilted and appliquéd

The debt we all owe Nelson Mandela as human beings cannot be quantified. He fought for the rights of all people, he fought for a free and democratic South Africa without apartheid. Mandela was and is the physical embodiment of the struggle and triumph of good against evil.

Mandela is literally and figuratively depicted here as one with his beloved country. As a man of the people, he is made of the very fabric of the South African flag — the green black and yellow of the African National Congress, and the previous red, white, and blue of the former South Africa. He brought all of South Africa together and focused on healing rather than hate.

I call my quilt "Free At Last" because not only did Mandela prove to the entire world that as long as your mind is free, so will you be, but also he is now soaring with our great ancestors like Malcolm X, Mahatma Gandhi, and Martin Luther King. Martin Luther King gave the phrase "free at last" worldwide recognition in a speech, and I found it perfectly fitting here.

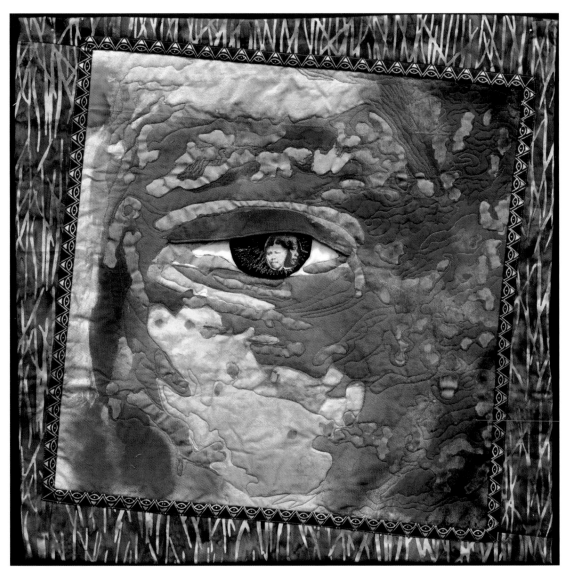

15. HELEN BUTLER
Pupil of the Eye 3
Evanston, Illinois, USA | Cotton, satin, Adirondack spray dyes, Lumiere acrylics, batting, rayon and metallic thread, Lutradur mixed media sheets; screen printed, whole cloth quilted, spray dyed, photo manipulated.

I love process, love watching how the germ of an idea unfolds, shifts, and then emerges from the invisible to the visible. There is a level of submission inherent in process that cannot be explained, only alluded to. There is mystery, there is faith, there is trust in the progression, there is patience, there is generosity, there is kindness, there is befriending the unknown. This shape-shifting dimension is abundant throughout creation but most welcomed in the arts.

Much of my work is framed by story. I believe that story is a primal form that joins object and people in a relationship. It gives context to life. My story with this quilt reflects a faith tradition that regards people of African descent as the pupil of the eye:
Thou art like unto the pupil of the eye
Which is dark in colour,
Yet it is the fount of light
And the revealer of the contingent world.
— 'Abdu'l-Bahá

Precious sight is accomplished because the pupil acts like a hollow reed. To my mind, Nelson Mandela demonstrated this power of precious sight as an example for all humanity.

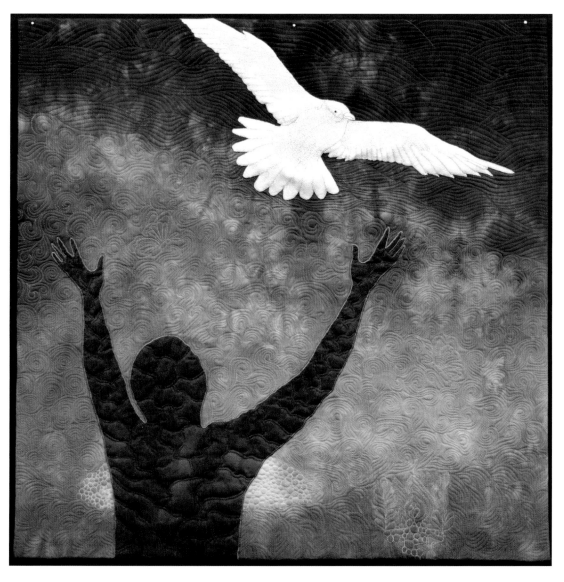

16. CYNTHIA H. CATLIN
Peace and Reconciliation
San Pedro, California, USA | Hand-dyed cotton fabrics, polyester, organza, and wool batting; machine appliquéd, thread painted, machine quilted, and trapunto

The artwork is dedicated to Nelson Mandela, the national healer and champion for social justice, equality, and education. I was inspired to honor freedom fighter Mandela because of what he stood for and the impact he had on the world. His was a legacy of commitment to democracy, equality, and public service.

In this quilt I hoped to capture his gentle spirit and non-violent ways, and to convey his regal but spiritual presence. The bird is a symbol of hope, peace, and love for all mankind. The silhouette with outstretched arms represents his call to God for comfort, resolution, and a cease of fighting. We are all infinitely richer for his service.

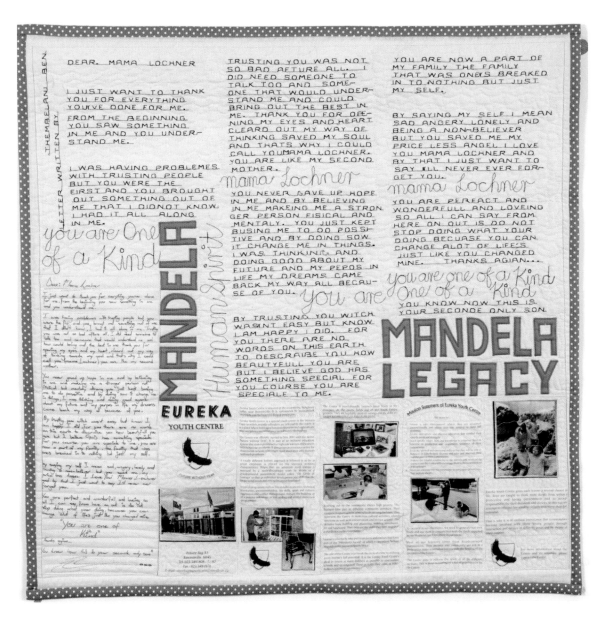

17. MARÍ CLAASÉ
Letter to Mama Lochner
Worcester, Western Cape, South Africa | Cotton; fabric printed and machine quilted, embroidered, and appliquéd

My quilt carries a copy of a touching letter that was written by a black South African youth Tembelani Ben to Tanya Lochner, his teacher at the Eureka Youth Centre School in Rawsonville, Western Cape, South Africa. This school was started in 2001 to accommodate juvenile offenders who had been referred to the school by the courts. It is a place where these youth are given a second chance to rediscover themselves; some, like Ben, undergo a completely new outlook on life. This story forms part of Nelson Mandela's legacy – the uplifting of troubled youths.

When I finished the quilt, I told the teacher that I planned to donate this quilt to their school once it is back from touring in the exhibition. I was informed that this school, and 3 similar ones, will be closed down in the very near future and that all these boys will be sent back to jail because the government no longer has the financial aid to support them. I find it rather shocking and it makes no sense to take away this very important opportunity to do something positive and constructive for its troubled young people.

18. ANDRENA STODDARD COLEMAN
A Man for All Seasons
Greensboro, North Carolina, USA | African fabrics; machine pieced, hand quilted

This quilt was inspired by my recollections of Mandela through news reports, articles, and conversations I had with others about the legacy of this great leader. My goal in making this quilt was to depict the life, challenges, and victories of a man who represented the plight of all people. The photographs chronicle his long walk, from a young man through his later years. The fabric, a collage of scraps I collected from a Nigerian dressmaker, represent the colors of all nations.

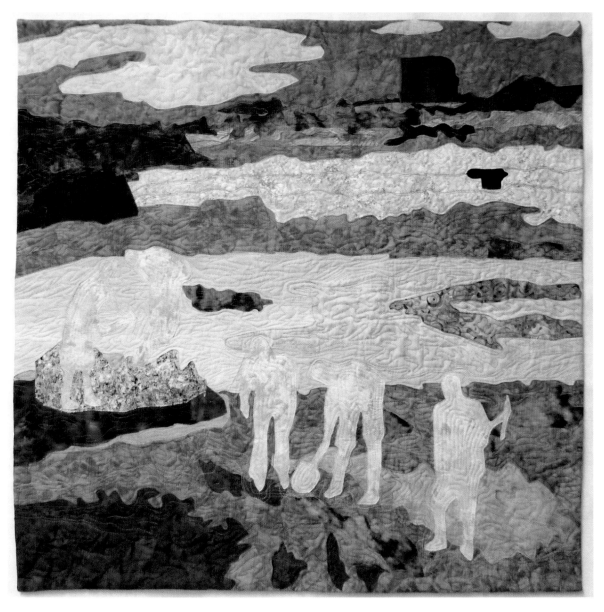

19. MARION COLEMAN
Quarry Ghosts
Castro Valley, California, USA | Batik cloth, thread; stitched, fused, fiber collaged

This quilt represents the spirits of prisoners held at Robben Island and how imprisonment failed to conquer their spirits. I hope that this educational social justice art quilt will move viewers to think about the trial of the ancestors and the efforts of all freedom fighters. I hope that it will help educate people of all ages about segregation, strength of spirit, determination, and forgiveness.

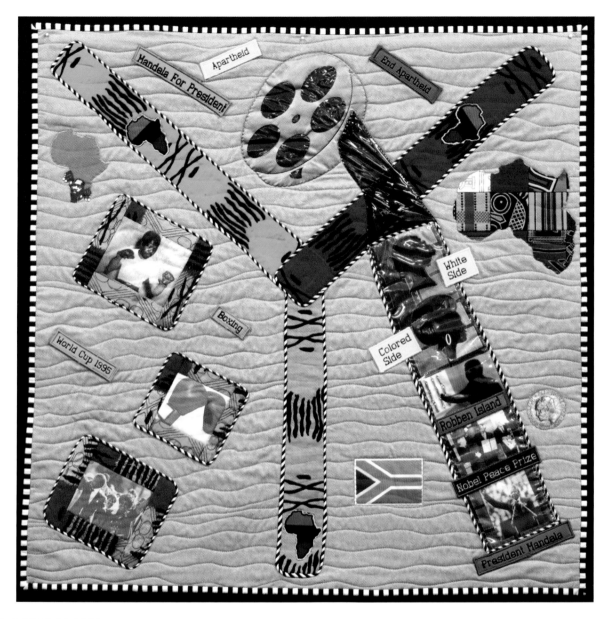

20. LAURA CROOM
Let Freedom Reign
Warrensville Heights, Ohio, USA | Cottons, vinyl, Lumiere acrylic paint, photocopies, variegated cotton thread; quilted, embroidered, painted

Mandela was a kind man who believed in peaceful harmony without any form of violence. He was awarded the Nobel Peace Prize along with President F. W. DeKlerk for ending apartheid and bringing about peaceful democracy to South Africa. The peaceful being inside this man was amplified when he was elected as the first black president of South Africa and he invited the men who were his prison guards to his presidential inauguration. I am always touched by his words: "As I walked out of the door towards the gate that would lead to my freedom, I knew if I did not leave my bitterness and hatred behind, I would still be in prison."

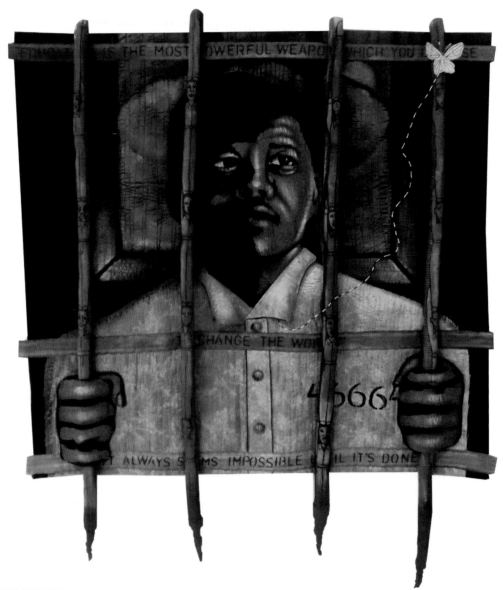

21. CAROLYN CRUMP
Wasted Years
Houston, Texas, USA | Cotton, hemp, and felt fabrics, paint; free-motion quilted and painted

Education is the most powerful weapon which you can use to change the world. It always seems impossible until it's done. — Nelson Mandela

Throughout history bars have always been used to confine animals, protect property, set boundaries, and isolate criminals. This was not so in the case of Nelson Mandela. He surrendered to the bars and laws of that day because he knew that imprisonment was a small price to pay for the cost of freedom for his people; the bars could not stop his quest.

This work aims to show the strength and courage of man who knew that his love for his fellowman was stronger than any bars that he would ever face. This great and wonderful man never allowed the bars or time to shake his soul or his mission. No matter what he endured, he maintained hopes of a brighter day. Giving up was not an option, he was determined that having begun a good thing, he and his fellow activists would see it through to completion. The bars of the jail cell represent his faith, hope, trust and sacrifice.

This man showed the entire world that one person can truly make a difference. Madiba, though your spirit has now been set free, a grateful nation and, yes, the entire world honors you.

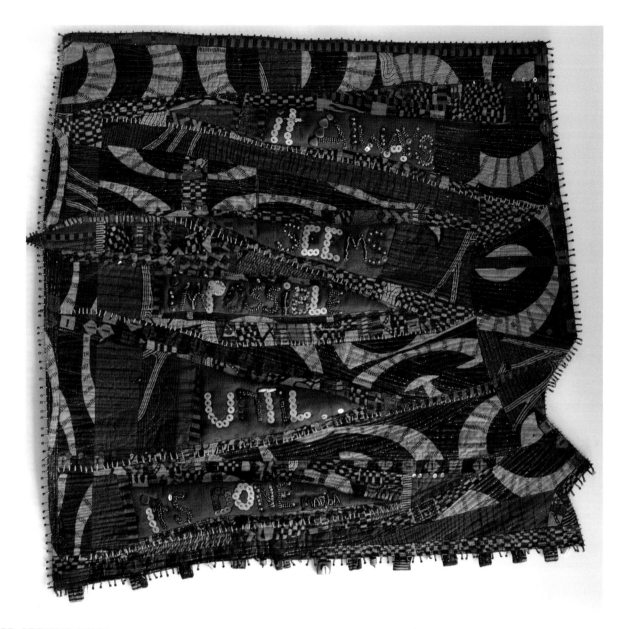

22. ADRIENE CRUZ
It Always Seems Impossible Until It's Done
Portland, Oregon, USA | Fabric, sequins, beads, mirrors, crushed lemon verbena

As an abstract artist it was quite a challenge to design a work honoring Nelson Mandela. After careful consideration it seemed a quote might be the way to go but how? Unsure of the outcome, I started beading his words on strips of woven fabric and the design then came together with the placement of his words. His journey of many rivers to cross came to mind and then meditation on his quote guided my process. It was a pleasure and an honor to create this piece.

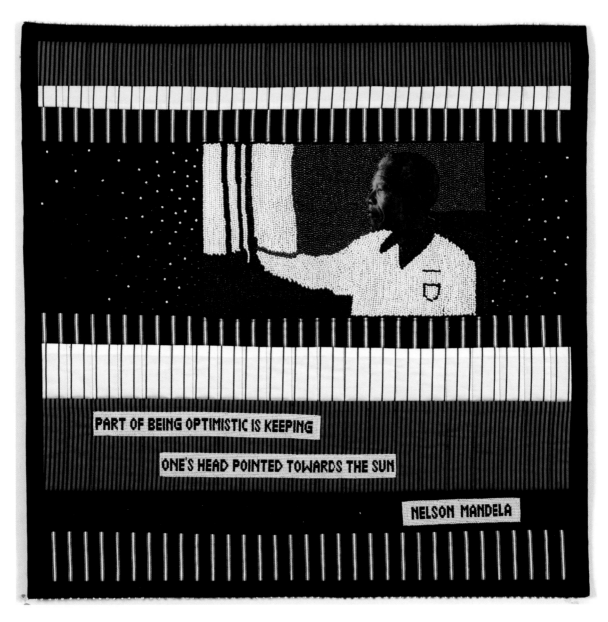

23. CELIA DE VILLIERS AND TALKING BEADS
Sunshine and Shadow
Pretoria, Gauteng, South Africa | Fabric, beads; pieced, beaded

This metaphoric, collaborative work is based on a photograph of Nelson Mandela in the well-known series by Louise Gubb. The selected image was of his return visit in February 1994 to his Robben Island prison cell. In the Xhosa tribal tradition of Nelson Mandela, white beads represent a link to the deceased ancestors and black beads signify unity and strength. The poignant words beaded on this quilt were spoken by Nelson Mandela during deliberations on his long term of imprisonment. The selection of striped fabrics reference the shadows cast by the prison bars in his cell. They simultaneously evoke piano keys and the words of the song by the musicians Paul McCartney and Stevie Wonder:
Ebony and ivory live together in perfect harmony
Side by side on my piano keyboard, oh Lord, why don't we?

This is precisely the spirit of the alliance between de Villiers and Talking Beads, a craft artists cooperative. In the quilt, visual language becomes a tool for the association of social and artistic contextual relationships.

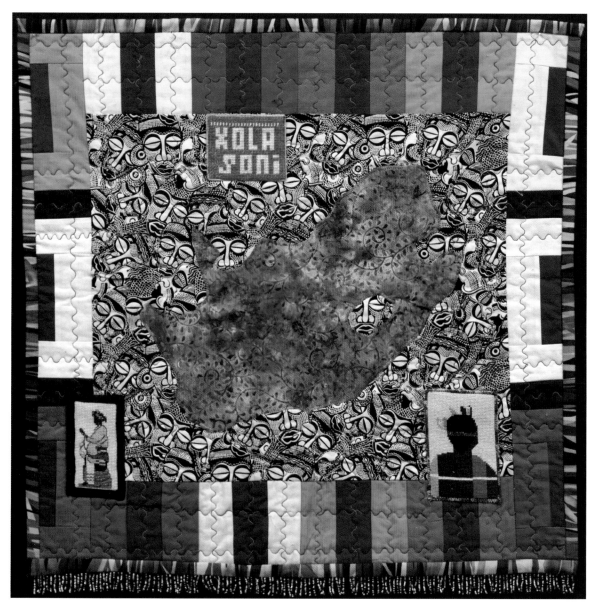

24. JACQUELINE DUKES
Transition: Toward Including Africans in South Africa's Promise
Shaker Heights, Ohio, USA | Cottons and beads; machine pieced and quilted, needlepoint appliquéd

Being of a certain age and having grown up Black in the Unites States, I am extremely empathetic toward the challenges of the indigenous peoples of South Africa. Being devalued, suppressed, and derailed in one's own homeland must have been almost unbearable. I visited South Africa in 1998 as part of a teacher exchange program and felt immediately connected. My quilt is a love note to the people of South Africa and to recognize Nelson Mandela's role in trying to bring the ignored into the democratic process, to be inclusive, and to share the resources of a mineral rich nation still in transition.

The mask motifs used here represent the many people whose lives were sacrificed during the struggle for justice. I included two women, one Xhosa and one Ndebele, because women carry and nurture the children and because many women do hand work—as do I. With this quilt I honor an insightful man who represented the collective effort to regain a place within one of the most beautiful countries I have ever seen.

25. ELMIRA ESSEX-SIZEMORE
Simple Words for a Great Man
Pittsburgh, Pennsylvania, USA | Cotton fabric, cotton batting, silk and embroidery threads; machine embroidered and quilted

Quiltmaking provides me with an inner peace and sense of self-satisfaction, helps me reduce stress, and helps me get through some difficult times. This quilt has helped me reduce some of the anger I have felt about the injustice done to Mandela. As I stitched out the words I could feel the release, and knew that if he forgave the injustice then I could do that also. Making this quilt was a powerful experience for me and it is the first quilt I have made that speaks to social justice.

My daughter and I cried the day Mandela was released from prison. I wept because it was such an injustice to see this man have his life taken for no other reason than his desire for justice and equality for his people. As I write this statement I still weep to think about all those years he lost from his family and from society.

Mandela: A Humble Servant of the People

26. IFE FELIX
Mandela: A Humble Servant of the People
New York, New York, USA | Cotton fabrics; appliquéd and machine-sewn

When Mandela came to the U.S. in 1990 he went to Harlem, a neighbourhood in New York City; I was there and my memory of the day was the inspiration for this piece. Mandela was scheduled to give a speech in late afternoon but people began arriving early, some even camping out the night before, in order to get a look at the man who had spent 27 years in jail in apartheid South Africa. By the time I arrived around 11:00 a.m., the crowds were enormous on the streets, on rooftops, fire escapes, and looking out windows. By 4:00 p.m. the sea of people was as far as one could see. Every now and then a chant arose of "Mandela, Mandela, Mandela." Around twilight word spread that he had arrived; the crowd came to a hush. He stepped to the podium and the crowd erupted into chants, tears, cheers, and applause. People overwhelmed with emotion held hands as Mandela spoke. His voice resonated into the crowd and we hung on his every word. His hope for the future became our collective hope.

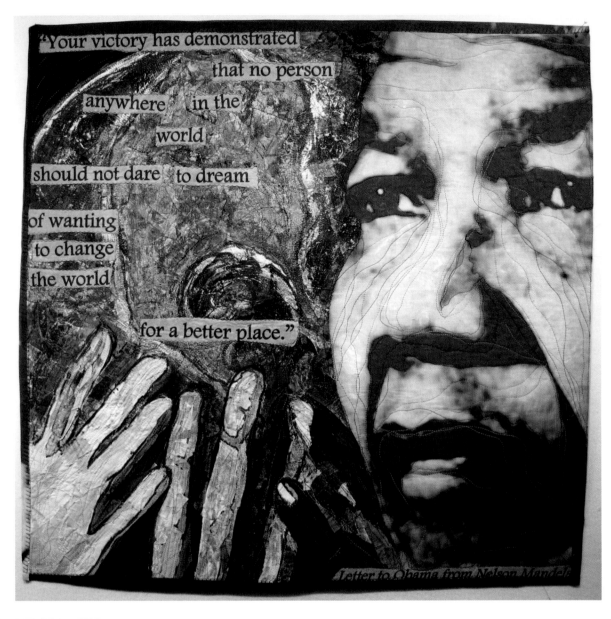

27. DEBORAH FELL
Dare to Dream
Urbana, Illinois, USA | Cotton, canvas, paint, gel medium, repurposed fabric scraps, cotton voile, cotton thread; raw edge appliquéd, digital photo transferred, painted, machine stitched

Your victory has demonstrated that no person anywhere in the world should not dare to dream of wanting to change the world for a better place. — Nelson Mandela

These words, written by Nelson Mandela to Barack Obama on the day that Obama was first elected president capture Mandela's wish not only for Obama, but for the world as well. Mandela taught the world to dream and to reach for the impossible; he taught the world how to forgive and how to persevere no matter how challenging the circumstances. Mandela made the world a better place through his courage, perseverance, and fortitude. This quilt is meant to remind us that one person can make a difference.

Mandela is seen here superimposed over the world. North America not only represents where I live, but also exemplifies that Mandela's influence reached much further than South Africa. Children's hands—brown, white and black—holding up the world remind us that Mandela's message crossed oceans and racial barriers; it also reminds us that the world is in the hands of our children, our future.

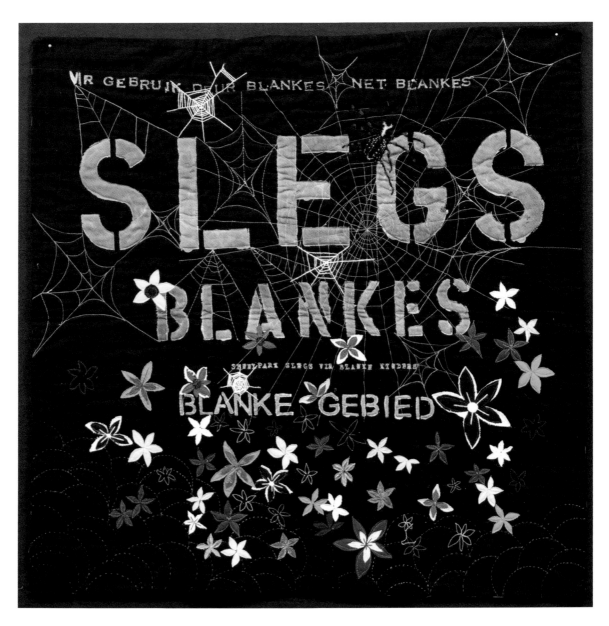

28. MICHELLE FLAMER
Madiba's Garden
Wynnewood, Pennsylvania, USA | Stencils with discharge on commercial cotton fabric, cotton, bamboo and wool fibers; raw edge machine appliquéd, machine and hand quilted, hand embroidered

There are at least two species of spider named in honor of President Nelson Mandela. The spider is an appropriate tribute to Nelson Mandela's tenacity and unwavering commitment to end apartheid. Spider webs are stronger than steel and become even stronger when a strand breaks. Nelson Mandela courageously endured an unjust prison sentence for twenty-seven years. The South Africa orb spider can spin a web several feet wide. Like a web, Nelson Mandela's influence spread across the globe and, even after his death, his strength and grace are enduring.

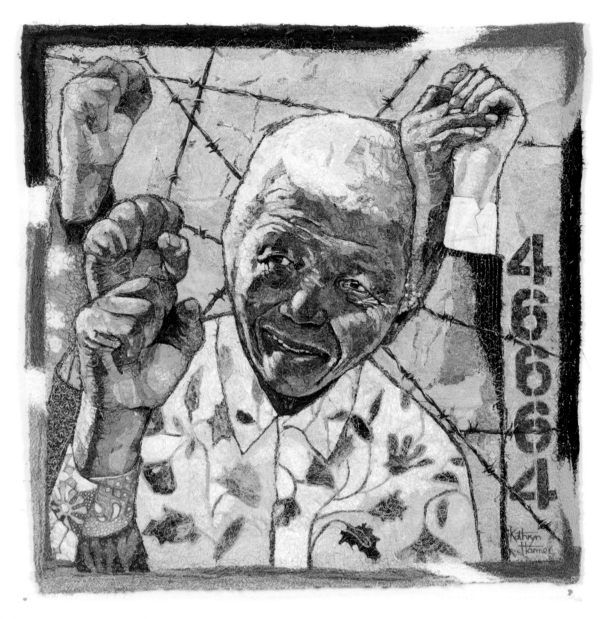

29. KATHRYN HARMER FOX
A Fistful of Freedom
East London, Eastern Cape, South Africa | Fabric, thread, handmade paper, used tea bags; fiber embedment using scribble stitch, free motion machine embroidered and quilted

Mandela was an incredible human being who made me proud to be a South African. He was a very rare politician— able to instill pride in the present, belief in the future, and forgiveness for the past. For this quilt I chose reference images that show his kindness, his humanity, and his strength of character. I wanted to show more than just the formal façade of this powerful statesman without ignoring his political message. I chose an image of an older man, one where his life is written in the many creases and furrows of his face. His inelegant hands (those of a boxer), raised in fists, are an expression of hard-won freedom rather than militant aggression. As he was able to unite black and white in hope, I included an image of Mandela's black-skinned hand clasping that of de Klerk's white one and lifting it in triumph. Lastly, I included the obvious symbols of barbed wire and his prison number; I firmly believe that it was during his many, many years of forced confinement that he became one of the greatest men of our time.

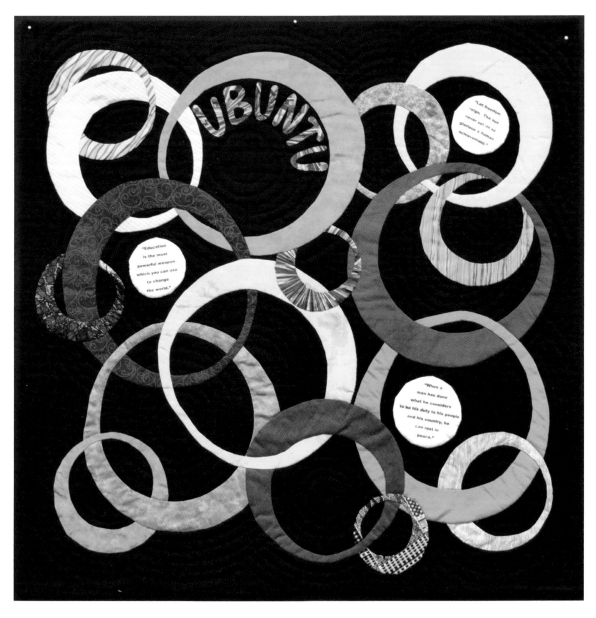

30. MARJORIE DIGGS FREEMAN
Ubuntu: Mandela's Greatest Gift
Durham, North Carolina, USA | Cotton fabrics and thread with cotton and polyester Hobbs black batting; hand appliquéd and quilted

Mandela knew that the only way to achieve real freedom and peace was through the mutual acceptance and understanding of all individuals and the recognition of *ubuntu*, the oneness of humanity and the universal bond that connects us all. His deep belief in the idea of *ubuntu* is worthy of practice by everyone, everywhere, forever.

The design of this quilt had to be as abstract as the concept of *ubuntu*. In this piece, *ubuntu* is symbolized by the colors of the South African flag with interlocking circles representing acceptance, harmony, and mutual understanding. On the three solid circles are quotes of timeless value by Mandela. Perhaps the visual simplicity of this quilt will remind people of *ubuntu*, this great tool for achieving harmony and peace on this planet.

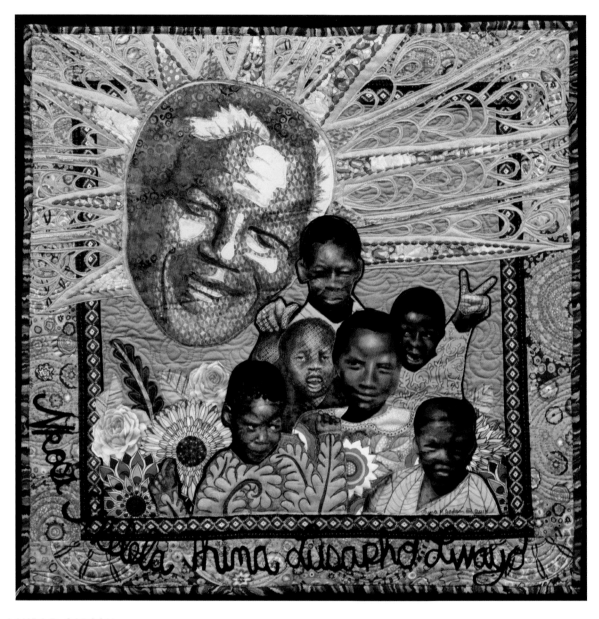

31. LAURA R. GADSON
Madiba Shines and Good Things Grow
New York, New York, USA | Printed cotton, beads, metallic thread, felt, Shiva oil sticks; machine appliquéd, pieced, and quilted, hand painted

Throughout the many stages of his life, Nelson Mandela demonstrated a passionate connection with the children of South Africa. His life's work and very being has emanated nurturing rays of hope and pride that are cultivating future generations and inspiring South Africa's leaders of tomorrow.

I had the great fortune to travel to South Africa in 1994 as part of a doll project that made and gifted Black dolls to South African children since the presence of Black dolls was limited during apartheid. While working for the Frederick Douglass Academy in Harlem, I designed a cloth doll and led students and their parents in the process of construction of 60 dolls. We then hand delivered them to day care aged children in South Africa. The children depicted in my quilt were some of those I met and photographed during the trip.

32. PAMELA GEORGE-VALONE
Harmonious
Pittsburgh, Pennsylvania, USA | Fabrics; pieced

Nelson Mandela strove for harmony in his personal life as well as the harmonious coexistence of all people, especially those in his own country. He felt that as one people, there is humility, mercy, justice, and harmony. That love for humanity comes more naturally to the harmonious human heart.

The placement of color, design, and pattern in this piece attempts to echo the harmony that Nelson Mandela struggled to lead his people to accept. This acceptance of harmony proved to have a profound impact on all of humanity.

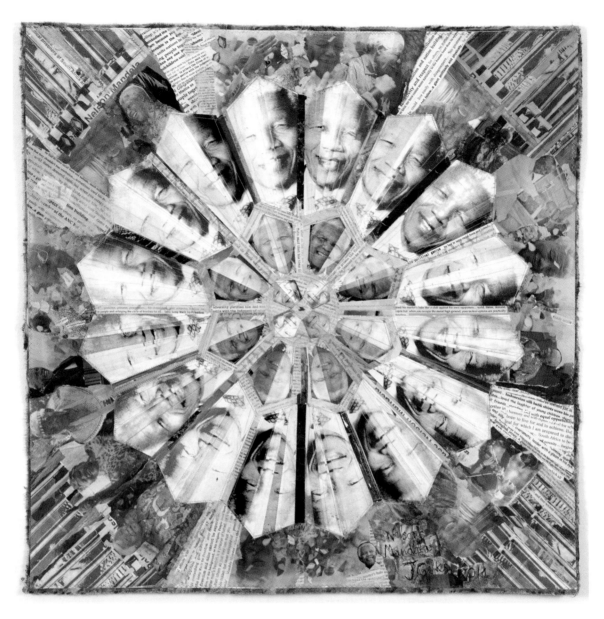

33. JEANETTE GILKS
Nelson's Mandala
Hillcrest, KwaZulu-Natal, South Africa | Newspapers, tracing papers, fabric stiffener, cotton thread, glue

Nelson Mandela's death in December 2013 triggered the media's floodgates world-wide and we all began to print the stories and the photographs of the man who had changed so many lives. I began to collect newspapers. Here were the ready-made stories of other people. Here was the material for my story.

I am intrigued with the relationship between words and visual images and what these different signs of things conjure up. What meanings overlap? What escapes the overlap? Perhaps a symbol - as opposed to a sign - points to things that escape absolute definition; escape any overlap, as a symbol expresses the inexpressible.
A pun compacts different ideas and associations. Nelson's Mandala, both a pun and a symbol, is thus a point of intersecting verbal, visual and conceptual ideas, the meanings of which are ultimately elusive. This overlaying of ideas is evident in the physical mechanics of collage: overlapping and gluing and sewing brings all the pieces together. Meaning can be constructed. Meaning is made by doing.

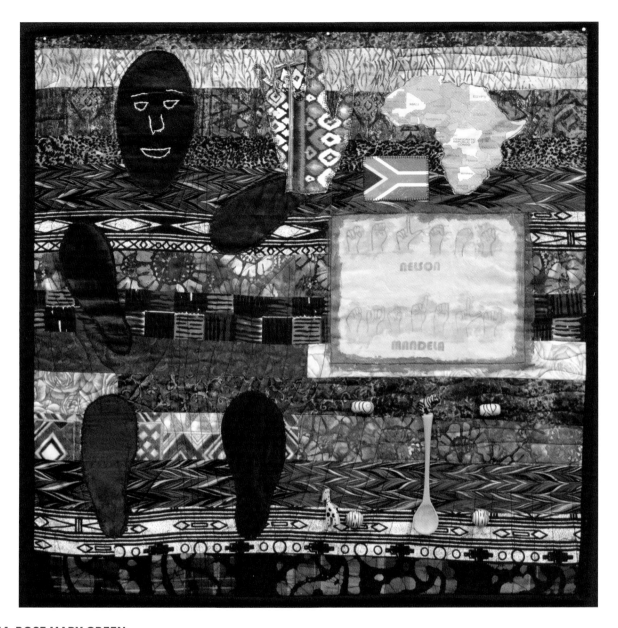

34. ROSE MARY GREEN
Celebration of His Walk
Cincinnati, Ohio, USA | Cotton batik, silk, canvas, beads, craft spoon with zebra head; machine appliquéd, machine free-motion quilted; hand sewn

This figure represents people dancing and rejoicing in celebration of Nelson Mandela's life. A life devoted to people of all colors working together for the betterment of mankind. The American Sign Language (ASL) sign for "I love you" shows people's love for him.

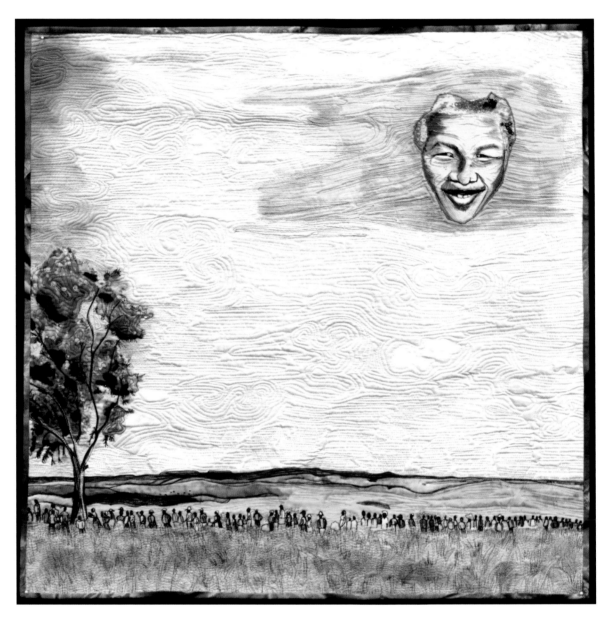

35. SANDRA M. HANKINS
A Queue For Democracy
Lake Elsinore, California, USA | Ink printed; quilted

I intended this quilt to celebrate the life and legacy of the late Nelson "Madiba" Mandela. Along with Martin Luther King, Mandela is one of the heroes in our lifetime.

36. COLLEEN HARRIS
Catalyst: The Creation of A Rainbow Nation
Johannesburg, Gauteng, South Africa | Satin, taffeta, lamé, velvet, silk, brocade; curved and string pieced

Nelson Mandela was and still is an inspiration to all South Africans. For a man to spend 27 years in jail because he wanted equality for all South Africans and then be released and not be bitter and revengeful is nothing less than a miracle. How often does one hear "If Mandela can forgive, then so can I"?

He united a nation that was on the brink of a blood bath. He freed not only black South Africans but white South Africans as well. He set an example, not only for South Africans, but also for the whole world.

I found all the proceedings surrounding his death very moving. The nation came together, all races, religions and creeds, not so much to mourn his passing but to celebrate his life and what he had achieved – the creation of a Rainbow Nation.

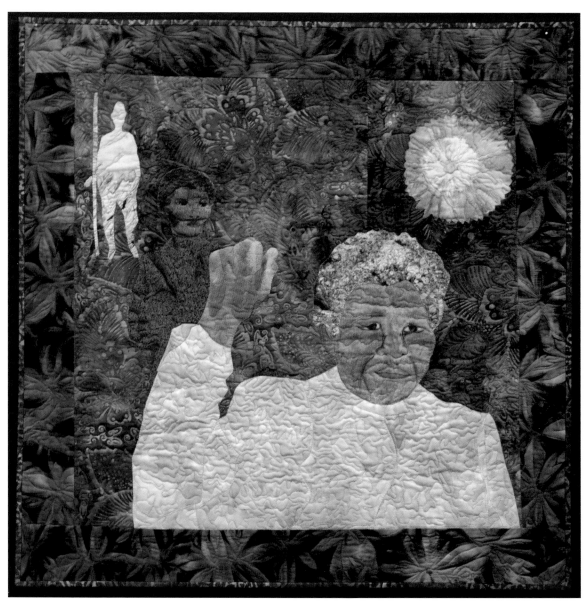

37. PEGGIE HARTWELL
The Mighty Warrior
Summerville, South Carolina, USA | Cotton, textile pen, and paint; machine appliquéd and quilted, painted

Mighty Warrior. The greatness of your strength was matched only by your devotion to peace and justice. Your journey was a courageous one. The world made note. Mighty Warrior, your vision refreshed the spirits of many. One day "justice and peace shall kiss" and the world again will make note.

38. JENNY HEARN
It Is In Your Hands Now
Johannesburg, Gauteng, South Africa | Hand-dyed cotton, commercial cottons, polyester batting; machine pieced and quilted, hand embroidered

I saw a billboard with Mandela's face and the words "It's in your hands now". The embroidery in my quilt implies that he held the different threads of this diverse nation together from 1992 to 1994, when the nation was very apprehensive about the future and was on the brink of civil war. The nation has now passed from one leader to another, and it is up to all South Africans to hold true to his legacy.

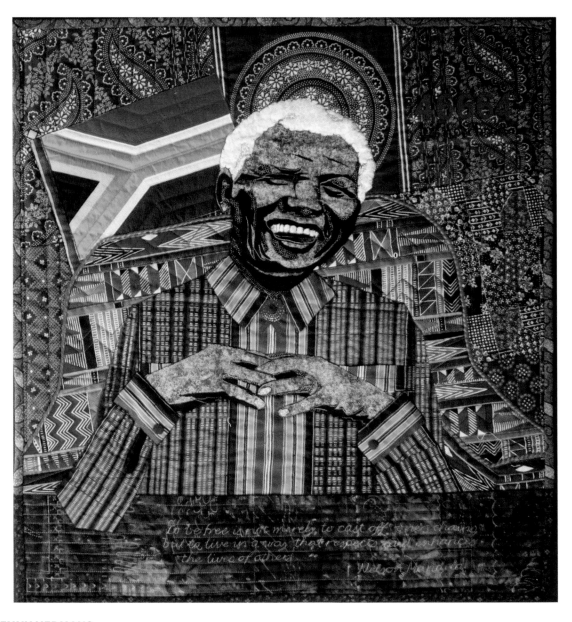

39. JENNY HERMANS
Icon
Pinelands, Cape Town, South Africa | Cotton, Shweshwe, and fabric of African origin; machine stitching and quilting | Photograph by René Hermans

On Mandela Day— the 18th of July—there is a call to pledge 67 minutes of your time in his honor. I started making this quilt on Nelson Mandela's 95th birthday; I thought about him, his smiling face, and hands with intertwined fingers. One month later, I completed the quilt.

The words on the quilt are a quote from Nelson Mandela: "To be free is not merely to cast off one's chains, but to live in a way that respects and enhances the lives of others." The number 46664 was Mandela's prison number; it is now used as part of his foundation's Aids Awareness Campaign. His words "It's in your hands" make us all conscious that we can do something about the situation.

The world over we mourn the passing of a great man. How fortunate we are to have lived in his lifetime to witness the extraordinary gifts he shared with us—amongst the many were compassion, forgiveness, and laughter. Mandela's love for family and his loyalty to friends and determination to strive for freedom for humanity are his lasting legacy.

40. MAYOTA WILLETTE HILL
Freedom Day
Pittsburgh, Pennsylvania, USA | Buttons, colored door key ID ring caps, fringe, embroidery thread, beads, shredded brown paper, and parts of a previously made quilt; appliquéd and embroidered

Story quilts are those that tell stories that describe various experiences and aspects of people's lives and of notable events, by way of visual display. This quilt displays the eventful period that began on February 11, 1990, the day that Nelson Mandela was freed after serving 27 years of a lifetime prison sentence. Great joy, which this quilt represents, was experienced by his family and faithful followers who had awaited his freedom, a freedom a "long time coming". Mandela's confinement was due to his undaunted activities that opposed apartheid in South Africa and his refusal to compromise his unselfish position.

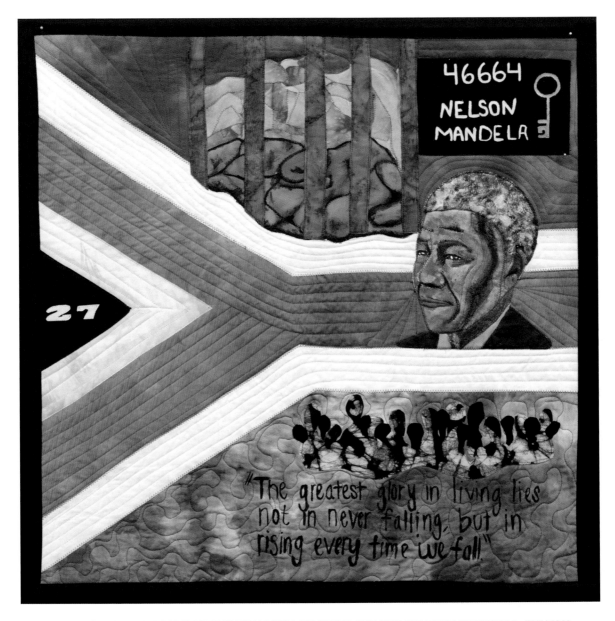

41. MARLA A. JACKSON WITH KEARSTON MAHONEY, SOMMER FERGUSON, TORI MITCHELL, SYLVAN MITCHELL, TEAGAN HARMON, DESIREE POWELL, NIA RUTLEDGE, BELLA MYERS, AND BREANNA BELL
46664
Lawrence, Kansas, USA | Cotton fabrics, bias tape, acrylic paint; trapunto, quilted, painted

This quilt was made as a project in the Beyond the Book program I founded. The program is designed to help students literally go beyond the book and develop a better understanding of history through art and quilt making. For the background of this quilt, students ice dyed cotton fabrics the colors of the South African flag. Mandela's face includes the colors red, black, green and yellow to represent the people of South Africa. The students chose to include a famous quote by Mandela "The greatest glory in living lies not in never falling, but in rising every time we fall".

Nelson Mandela was in prison for 27 years at Robben Island, Victor Verster, and Pollsmoor prisons; while at Robben Island he worked breaking rocks. To represent this there are prison bars on the top of the quilt over rocks and includes Mandela's prison number 46664. The first three digits meant that he was the 466th prisoner, and the last two digits indicated the year, 1964, he went to prison. His cell number continues to remind people of his quest for freedom.

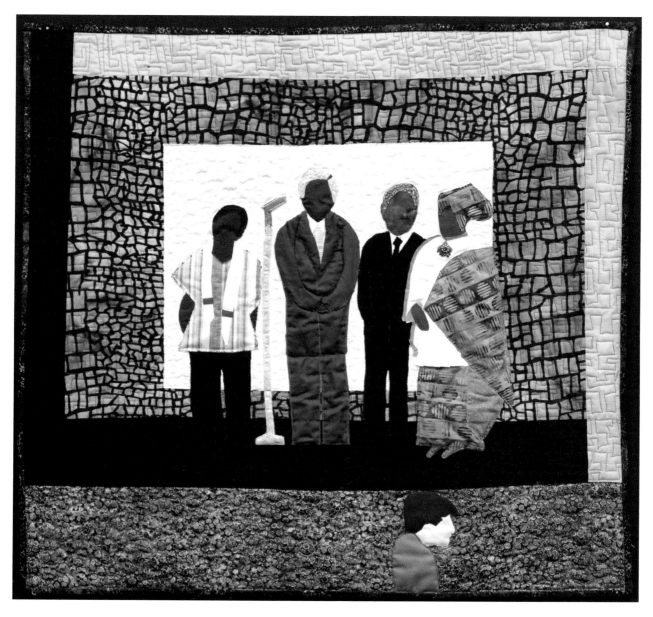

42. JACQUELINE JOHNSON
New York Welcomes Nelson Mandela
Brooklyn, New York, USA | Cotton fabrics and batting; machine and hand appliquéd

Quilts are not just for keeping one warm, they are also for healing and bearing history both personal and communal. This quilt was made to commemorate an historical event as the label on the quilt reads: "On June 20, 1990, shortly after they entered the United States, Nelson Mandela and Winnie Mandela came to Bedford Stuyvesant in Brooklyn on their way to City Hall. They were accompanied by New York City Mayor David Dinkins, Harry Belafonte, and a host of local and national figures.

This quilt is based on photographs from that historic day." I was happy I was able to locate the photographs as I wanted to use something that came from my own archive to make this quilt. Some of my impetus lay in the fact I knew very few quilters if any would have these particular photographs or point of reference. In my twenties I went to many "Free South Africa" events and fundraisers. I have been privileged to observe the birth of a new South Africa and to both witness and celebrate Nelson Mandela's legacy.

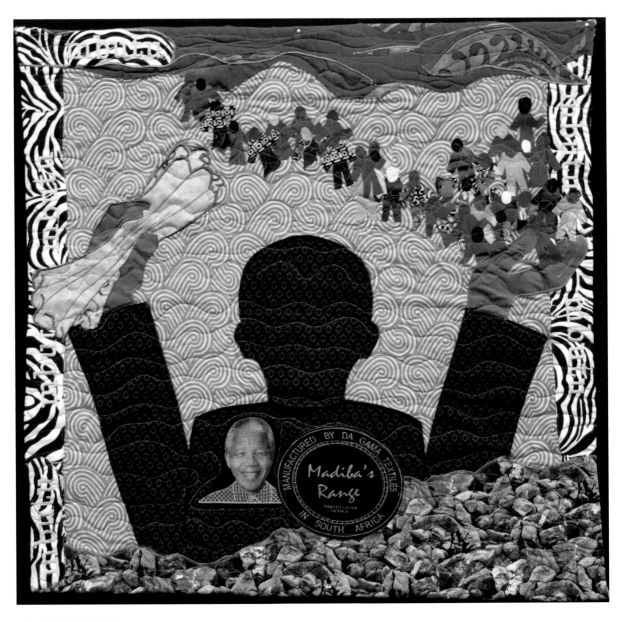

43. GLORIA KELLON
Madiba's Range
Shaker Heights, Ohio, USA | Cotton fabric, embroidery thread, commemorative fabric for Mandela; appliquéd and embroidered

Nelson Mandela was a selfless man who garnered world respect because of his determination for political freedom. There is no doubt that Nelson Mandela's journey to achieve his dream was long, dangerous, and unbelievably resourceful; it showed his desire, selflessness and intelligence. Much was sacrificed—a normal family life, good health, and, most important, his freedom. Out of his difficult journey, the feeling of *ubuntu* emerged. His endurance led to laws being changed and people uniting.

Mandela lived to see his rising sun and a new South Africa. Mandela's life story is a model of *ubuntu* or looking out for all people in your life goals. His journey to achieving freedom should be told in as many ways possible so that the next generation will pattern their lives for success. *Madiba's Range* is one way to show the passion and the enduring commitment a man will pursue to right the wrongs around him.

44. SHARON KERRY-HARLAN
Awakening
Wauwatosa, Wisconsin, USA | Artist designed hand-pulled silk screens, discharged dyed cloth, glass beads, vintage buttons, sequins, distressed cloth; painted, stitched, embellished

Nelson Mandela's passing awoke in the world a spirit of selflessness. It called forth in our minds such accomplishments as ending apartheid and becoming president of South Africa. Mandela's spirit lives in our hearts. Mankind celebrates his bravery, tenacity, and sacrifice. He left the world better for all people.

45. JILL KROG
Inspirations
Howick, KwaZulu-Natal, South Africa | Cotton, African Sky fabrics; machine pieced

I believe Mandela's greatest legacy lies in the powerful statements he made. From his emotional speech at the opening of the trial that would see him jailed for 27 years to the pleas for South Africans to come together when he became South Africa's first democratic president, words were his greatest weapon.

I never had the privilege of meeting Mandela personally. It is through my son Halden's eyes that I knew Mandela. Halden, a newspaper photographer, met Mandela on several occasions. Over the years they developed such a special relationship that Halden photographed the Mandela family numerous times in a personal capacity. Halden would tell me of Madiba's compassion, sincerity, honesty and humility; he explained to me that one always left Mandela's company feeling as if one were a better, more virtuous person.

I have used Halden's photographs, including some never before published, and some of Madiba's words in this quilt. Just as the quilter takes patches of material — new and old — to create beauty, so Mandela created a new social fabric with a patchwork of South Africans.

46. BETTY LEACRAFT
Amandla!
Philadelphia, Pennsylvania, USA | Cotton, polyester batting, textile paint, cotton and polyester threads; pieced, quilted "in the ditch"

I have always had great respect for the late Nelson Mandela and his struggles against apartheid and the liberation of Black South African people. I watched his historic release from prison on television and joyfully cheered his equally historic election.

As my idea for this quilt took shape I asked Godfrey Sithole, a South African Zulu living in my city, who has been a member of the ANC over forty years, about the significance of the colors of the ANC flag. He shared:
"The flag is made up of equal horizontal bands of black, green and gold. The black symbolizes the people of South Africa who for generations have fought for freedom. The green represents the land, which sustained our people for centuries and from which they were removed by colonial and apartheid governments. The gold represents the mineral wealth and other natural wealth of South Africa, which belongs to all of its people, but which has been used to benefit only a small racial minority.

Central blocks contain ANC flags with connected black bands to represent Black South Africans joined in solidarity against oppression."

47. CYNTHIA LOCKHART
Mandela / Prince of Freedom
Cincinnati, Ohio, USA | Silk screened and painted fabrics, upholstery textiles, lace, netting, wire, beads, braids, yarns, and miscellaneous fibers; hand and machine quilted, appliquéd, bias French edged, collage, draping and layering techniques

My artwork celebrates Nelson Mandela as an extraordinary humanitarian who fought for freedom for his country South Africa. Mandela's quest and his life's work cost him great sacrifice, however the reward was nothing short of miraculous. Imprisoned for 27 years for standing up against apartheid, he carried himself like a warrior Prince. With dignity and honor, he fought for the freedom and rights of Black people.

The mask in this quilt depicts Mandela as a warrior wearing a crown. He also has a shield of protection around his neck just as truly the hand of God watched over Mandela in prison and through the turbulent freedom struggle times. The celebratory colors represent the joyful energy, victory and majesty of a Prince of Freedom, the former inmate who became the first Black President of South Africa. In this quilt I believe I captured his spirit of hope, joy and enthusiasm and hope that it inspires others to remember the power of a great man who had so much passion for his people.

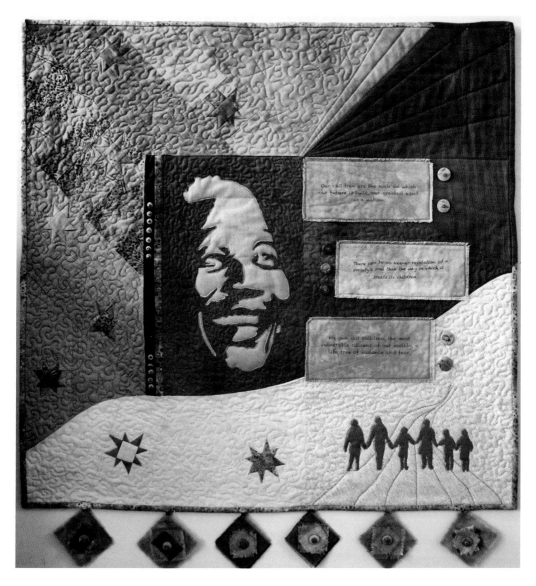

48. SANDRA MACGILLIVRAY
Twinkle, Twinkle Little Star
Canmore, Alberta, Canada | Cotton, hand dyed and commercial, machine pieced and appliqued, paint, African wooden and glass beads, leather | Madiba silhouette courtesy of www.fxpapercuts.com | photograph by the artist

Although I am now back in Canada, I was lucky enough to live in South Africa for three years. I had many experiences there which will stay with me for life. One of these is the enduring love and respect expressed for Nelson Mandela by so many of the people I met while I was there.

I chose to focus on Madiba's work to better the lives of South Africa's children. In 1995 the Nelson Mandela Children's Fund was established. The work of the NMCF is based on the belief that all children have dreams and aspirations and should thus be afforded the opportunity to reach their full potential. A vast amount of money has been raised under the NMCF umbrella which has meant many positive changes for South Africa's children. Recently ground was broken on the Nelson Mandela Children's Hospital and it is slated to open early 2016.

Madiba often sang 'Twinkle, twinkle little star" with the children he met to put them quickly at ease. This really resonated with me. Music has always played a major role in my family. When my father died last year my sister and I altered the words to a hymn we loved to hear him sing and then recited it as a poem at his funeral. "A sigh in the night and a star is born". I imagine that as each person leaves this world, in the heavens a new star is born. I am sure that Madiba's star is watching over us and shining very brightly.

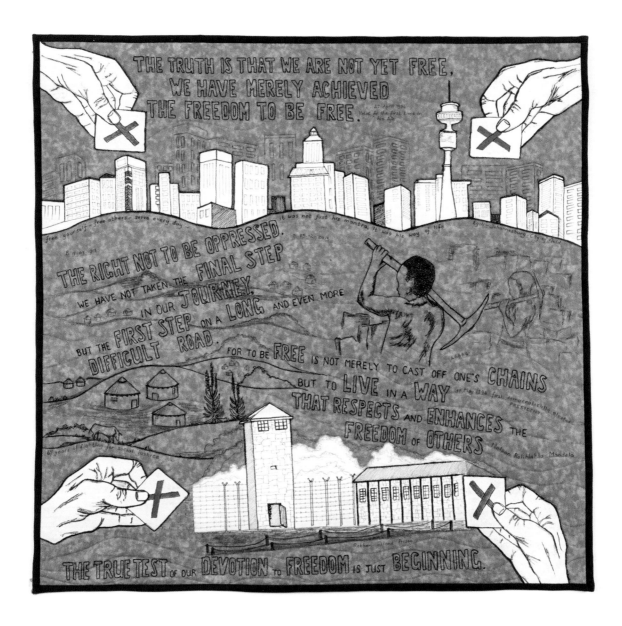

49. MADELINE MARSBURG
From Herd Boy to Global Icon
Cape Town, Western Cape, South Africa | Cotton fabrics; machine appliquéd, free motion stitched, thread painted, artist brush pen work

There are so many priceless painting and artifacts in museums and private collections around the world but none can compare to the humble quilt, made and given with love, creating friendships, bonds and gratitude that no wars can destroy or politicians can ever hope to acquire.

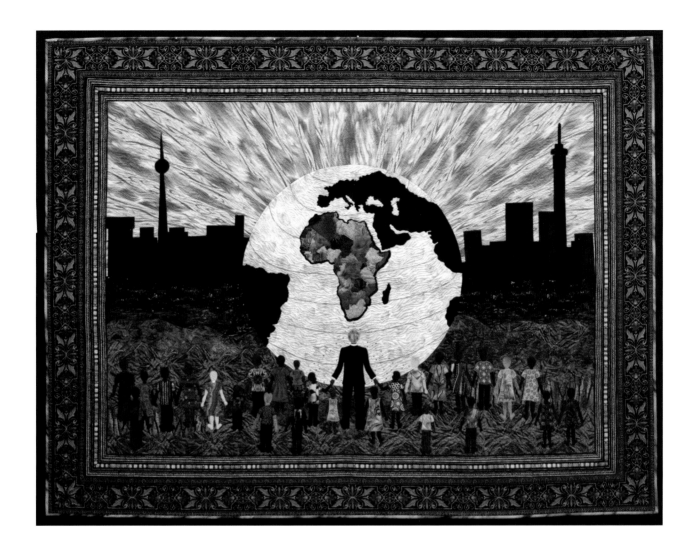

50. BARBARA ANN MCCRAW
Lead From The Back
Denton, Texas, USA | Cotton fabrics, seed beads, crystals; machine appliquéd and quilted, hand beaded

Even though I have been sewing for nearly 20 years and have taught and lectured on quiltmaking for the past eight, it was still a challenge to work through to the completion of this quilt. At times, it was an overwhelming task to express my feelings of honor and gratitude to a man that has impacted the lives of so many.

I received information for the Conscience of the Human Spirit project last fall. As with any new project, the first thing I must do is to mentally commit to the project; for several weeks I think about it, pray about it, study and research it. The most astounding thing that happens is that I usually wake up one morning and the finished quilt appears to me. The day I received my vision for this quilt, I excitedly made my way to my workspace and started sketching. As I was finishing the quilt my husband read to me something that Nelson Mandela had said, *"Lead from the back, and let others believe they are in front."* It seemed like the perfect name for my quilt.

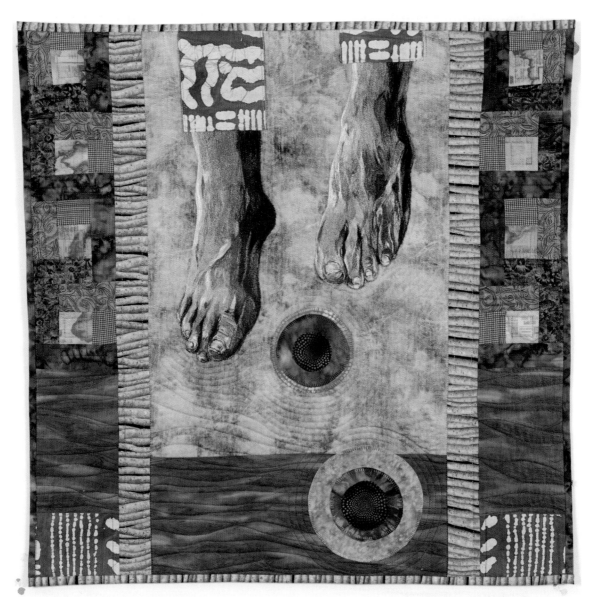

51. ANNETTE MCMASTER
A long walk to freedom: A tribute to the life of Nelson Mandela
Pietermaritzburg, KwaZulu-Natal, South Africa | Embroidery thread, cotton fabric; machine embroidered, pieced, quilted

When I started making this quilt I knew that I did not want to make an image of Nelson Mandela's face. I hoped instead to use the image of feet to evoke symbolic associations about his life and the sacrifices that he had made for all of us. His book *Long Walk to Freedom* inspired the initial machine embroidered feet. I used fabric that looked like the ocean and was reminiscent of the view towards Cape Town that Mandela had from his prison window on Robben Island.

I placed the feet at the top of the quilt because he was nearly hanged by the apartheid government; other viewers of the quilt might find religious associations with this placement. The fabric used for the prison pants was from a small piece that I bought years ago from a vendor from Maputo, Moçambique; Graça Machel, Mandela's third wife, was also from that country. The central blocks of the Log Cabin quilt pattern are photo transfers of newspaper articles of general life in South Africa; they show a contrast to his life of imprisonment and ours.

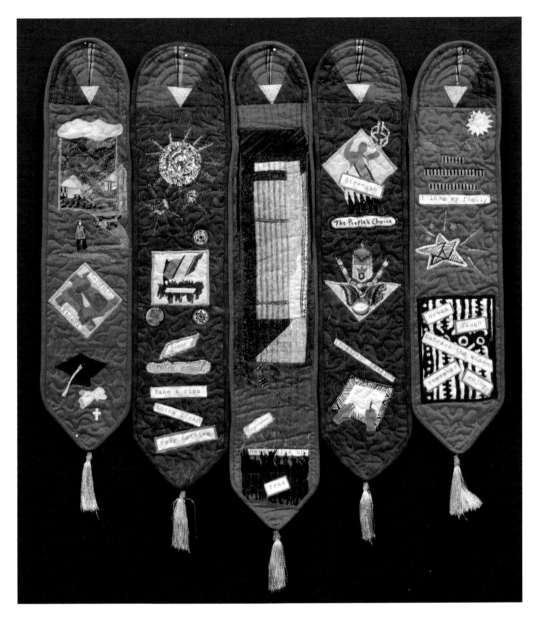

52. HARRIETTE ALFORD MERIWETHER
Windows of Reflections
Pittsburgh, Pennsylvania, USA | Cotton fabrics, gold tassels; appliquéd, pieced, gold embellishment

I made this quilt to honor the life of Nelson Mandela, a man who has inspired me and the world, by giving 67 years of his life to fight for the rights of humanity. His life parallels that of Martin Luther King, who stood against injustices experienced by African Americans, here in the United States. Like King, I grew up in Georgia, and I am stained by the blood of many and stand on the shoulders of those who left a legacy; "we must never give up until justice prevails". The five panels show phases of Nelson Mandela's life. The quilt can be presented as a storyboard to describe the life of Nelson Mandela for all age groups.

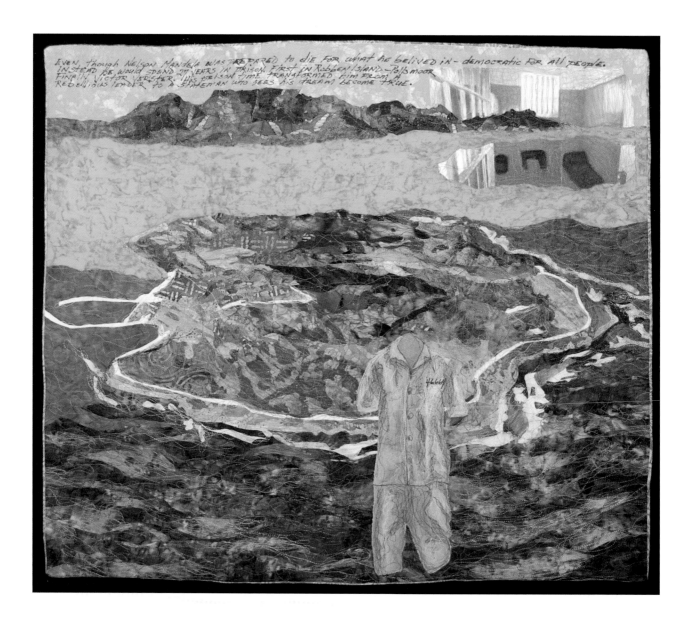

53. PATRICIA A. MONTGOMERY
Prison Time Transformation
Oakland, California, USA | Cotton and batik fabric, digital images, oil pastel, cotton and rayon threads; textile thread painted, fused, free motion machine quilted

Nelson Mandela was prepared to die for what he believed in - democracy for all people. Instead he spent 27 years in prison, first at Robben Island than at Pollsmoor and finally at Victor Verster. His prison time transformed him from a rebellious leader to a statesman who saw his dream, democracy for all people, become reality.

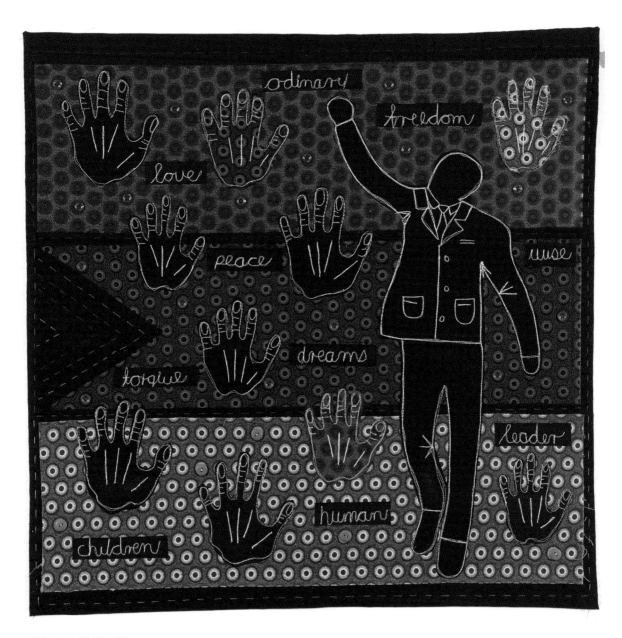

54. BARBARA MURRAY
A Nation's Hero
Newcastle, KwaZulu-Natal, South Africa | Shweshwe, cotton, buttons; raw-edge appliquéd, free machine embroidered, hand embroidered

How can we not want to make a quilt of Nelson Mandela? He was such an inspiration to so many and achieved so much; an ordinary man who became an extraordinary leader. As a lover of fabric I could not help myself paying extra attention to the shirts that Madiba was famous for wearing. I therefore decided to use the Shweshwe fabric for my background since this is a fabric unique to South Africa and commonly used in traditional clothing. The shape of my background also refers to our national flag. I depicted Nelson Mandela's silhouette, an image that became all too familiar. I added hands to refer to the Nelson Mandela's Children's Fund for which he did so much in life and death. I added words like freedom, peace, dreams – all things he believed in.

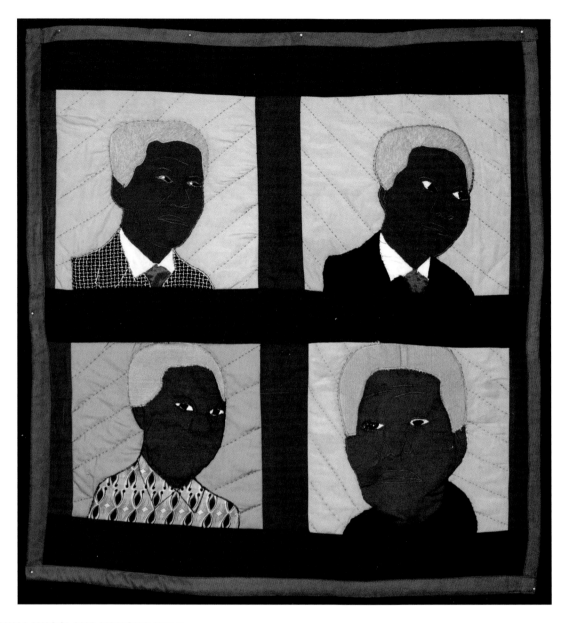

55. PHINA NKOSI AND VANGILE ZULU
Our Madiba
Johannesburg, Gauteng, South Africa | Cottons; machine pieced and appliquéd
Collection of Michigan State University Museum, 2014:24.1 | Purchased with support from the MSU Foundation and Office for Vice President for Research and Graduate Studies

This quilt is about our South African legacy. Madiba is our hero in South Africa. When we had no freedom, he was very, very strong for us. Our colors are all now free and we are one rainbow nation now through Madiba. Other countries, like Zimbabwe, are fighting but because of Madiba, we are at peace. He is the greatest man we can find in the whole world.

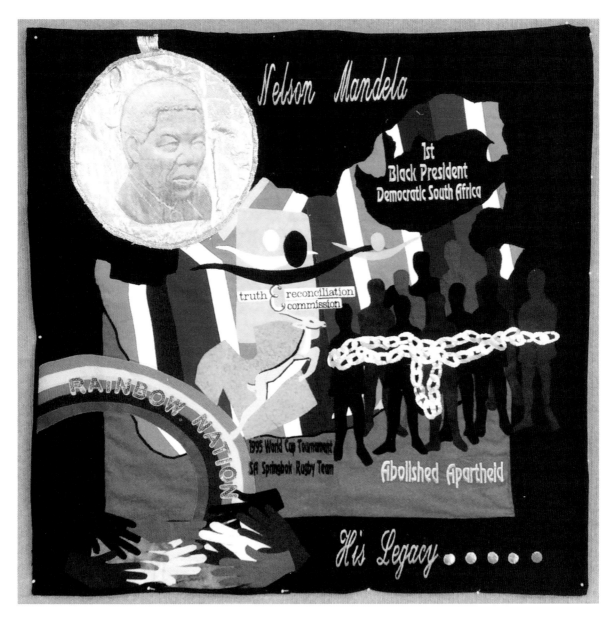

56. SANDRA E. NOBLE
Nelson Mandela, His Legacy
Warrensville Heights, Ohio, USA | Cotton, lamé, organza fabrics; appliquéd and fused

When I began this quilt in 2013 I realized that, although I knew of Mandela and some of what he had done, I needed to know more about him. Because it was soon after his death, there was an abundance of materials available and discovered many facts about his life I did not previously know about. I gained deeper appreciation for Mandela and his spirit of forgiveness after all his tribulations.

For this quilt, I chose to highlight major accomplishments made by Mandela that solidified his prominence. When I design a fiber piece, I struggle to visualize the face of the artwork, how all the parts need to fit together, even before drawing the composition on paper. For this piece I needed to consider what colors, textures, and fabrics to best represent his accomplishments. I chose bright colors and incorporated these words into the design: Rainbow Nation, Nelson Mandela, 1995 World Cup Tournament, SA Springbok Rugby Team, Truth & Reconciliation Commission, 1st Black President Democratic South Africa, and Abolished Apartheid.

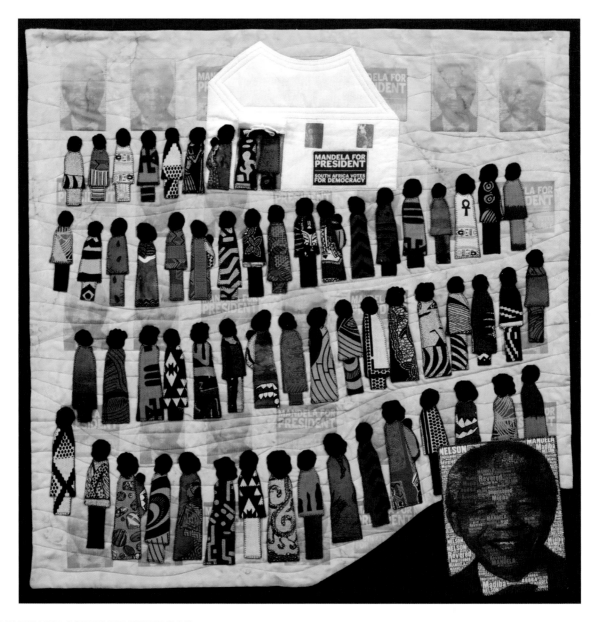

57. MARLENE O'BRYANT-SEABROOK
Madiba: From Prison to Reverence
Charleston, South Carolina, USA | Cotton fabrics (both U.S. and African),
transfer artist paper, felt; hand appliquéd, machine quilted

This quilt was created to pay homage to an extraordinary man, Nelson Rolihlahla Mandela, affectionately called Madiba. In 1990 I sat with anticipation waiting for the televised release of Nelson Mandela from prison. I expected to see a man who visibly showed the toll of 27 years in a harsh prison environment. Instead, I saw a tall, erect, majestic figure who had shed the number 46664 and strolled with a sense of purpose from prison into the hearts of those in his country and around the world.

Etched indelibly into my mind are also the news pictures of the queues of more than 16 million persons who stood in lines over a three-day period in 1994 to cast their votes in South Africa's first fully democratic election. I am aware that many were dressed those days in Western style clothing but, for the figures in this quilt, I chose to depict them in African attire because I was impressed with the number of Black South Africans who took advantage of this first-time opportunity to vote.

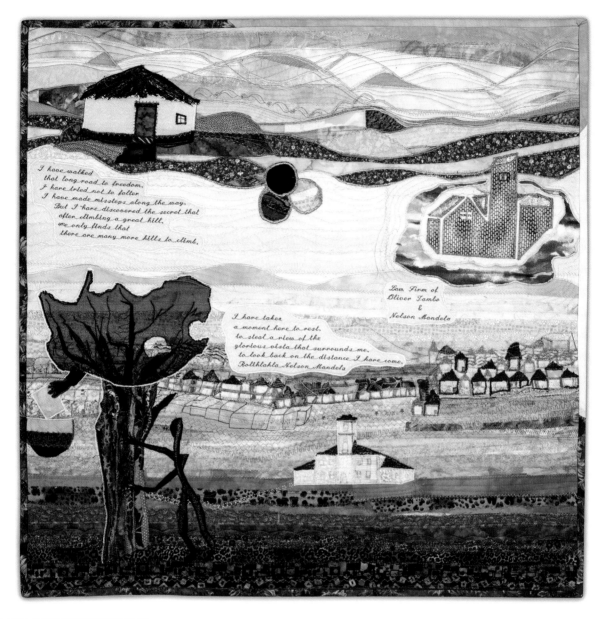

Within the quilt image (handwritten text):

I have walked
that long road to freedom.
I have tried not to falter.
I have made missteps along the way.
But I have discovered the secret that
after climbing a great hill,
one only finds that
there are many more hills to climb.

I have taken
a moment here to rest,
to steal a view of the
glorious vista that surrounds me,
to look back on the distance I have come.
Rolihlahla Nelson Mandela

Law Firm of
Oliver Tambo
&
Nelson Mandela

58. VALARIE PRATT POITIER
Trials, Tribulations, and Temporary Lodgings of Nelson Mandela
Natick, Massachusetts, USA | Cotton and metallic fabrics, cotton or polyester threads, netting; machine stitched, strip pieced, appliquéd

Each area of this quilt has an appliqué that represents a time in Mandela's life of great change for him, others like him, and for the different decision makers of his country. The tree, for instance, is made up of scraps representing the colors of his Xhosa traditional clothing. It also represents the unlikely parts that make up a society, different but each relying on the other for cohesion. The tree, with foliage in the shape of South, has been shaken and turned on its end by a figure representing Mandela, whose Xhosa name was translated by some as tree shaker or troublemaker. From the left side of the tree a brown hand holds a voting sheet being lowered into a basket in the colors of the African National Congress to which Mandela belonged.

What many people in the U.S. do not realize is that our country went through something similar to what happened in South Africa. This quilt gives me an opportunity to create a safe space to talk about issues of freedom and rights that occurred and are still occurring here in the U.S. today.

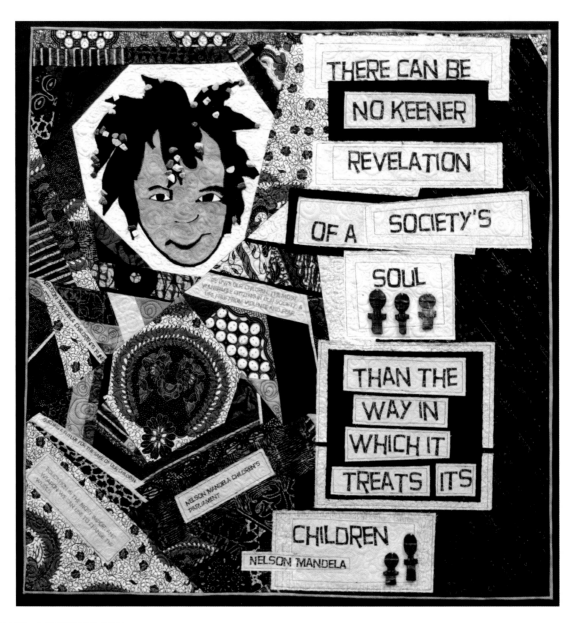

59. GLENDA RICHARDSON
Mandela, the Children's Advocate
Ft. Washington, Maryland, USA | Commercial cotton, tea dyed cottons, beads, bone pendants, photo transfers; machine quilted, appliquéd

During my research for this project, I noted that several sources mentioned that during his 27 years on Robben Island, Nelson Mandela was not allowed any visits by children. This was a harsh and dehumanizing punishment experienced by all of his fellow prisoners. Upon his release, Mandela delighted in the presence of children and became a staunch advocate. My quilt includes his most famous quote on the importance of the treatment of children: "There can be no keener revelation of a society's soul than the way in which it treats its children." It also includes additional quotes on the topic, and names of organizations founded by Mandela for the benefit of children.

The fabrics that I chose for this quilt are African and Indonesian themed. The complementary designs remind me of the "Madiba shirts" that Mandela often wore. The girl depicted on the quilt was inspired by a photograph of a beadmaker's daughter that I took on a trip to Ghana.

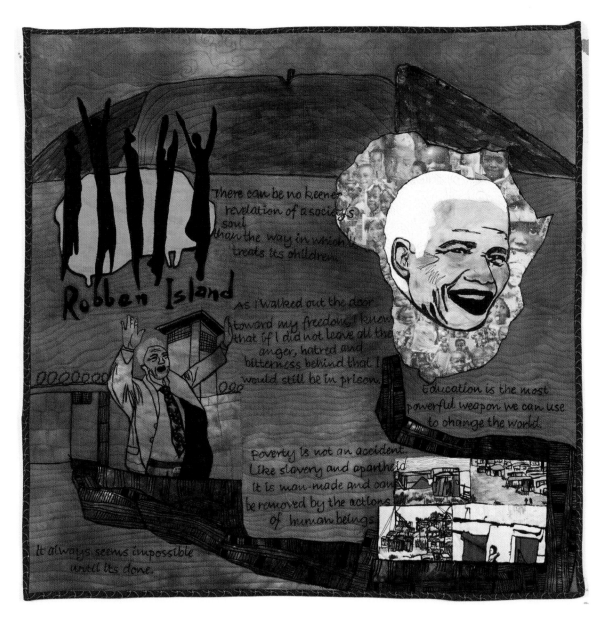

60. MORAG SCORDILIS
Priceless Threads of A Nation
Cape Town, Western Cape, South Africa | Hand dyed fabric, digital images on ink-jet printer enhanced with Derwent Inktense pencils and blocks; fused, machine appliquéd, free-motion thread sketched and free-motion quilted

Having trained and worked as a social worker during the apartheid years, the theme of this exhibition spoke to me and I simply had to make a contribution. My training and years working amongst the communities of the Western Cape focused on children and families and more specifically those communities ravaged by poverty and injustice. As I continue my work amongst adolescents in an educational setting I remain painfully aware of the challenges that our youth face on a daily basis. My quilting is both a way of coping with the stress and challenges of my job and a vehicle of expression and catharsis.

Included in the quilt are Madiba's powerful words on the subjects of poverty, education, and children and images of informal settlements, children, and the map of Africa. Madiba reminds us that one of the most powerful tools in the fight against injustice is education. Lest we forget, Madiba reminded us that the way in which a nation treats its children speaks volumes about our society. The work started by this great icon is not complete; his legacy is merely the beginning of *our* journey.

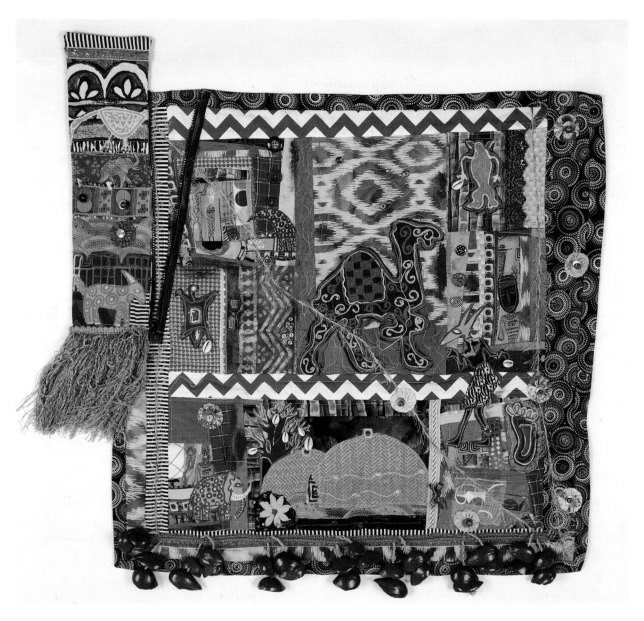

61. LATIFAH SHAKIR
To Johannesburg through the forest of my Africa
Lawrenceville, Georgia, USA | Recycled cotton clothing, African fabric, African dancer's Woven belt, cotton scraps; pieced, appliquéd, beaded, painted, hand and machine quilted

When Nelson Mandela's banning was lifted in 1952 and he was able to travel, he visited his mother and family in Johannesburg. En route he passed through several forests where he enjoyed sightings of animals; he referred to it as "the Africa of the storybooks." He found it haunting that South Africa could have such wealth of natural beauty at the same time it had such inequality for its citizens.

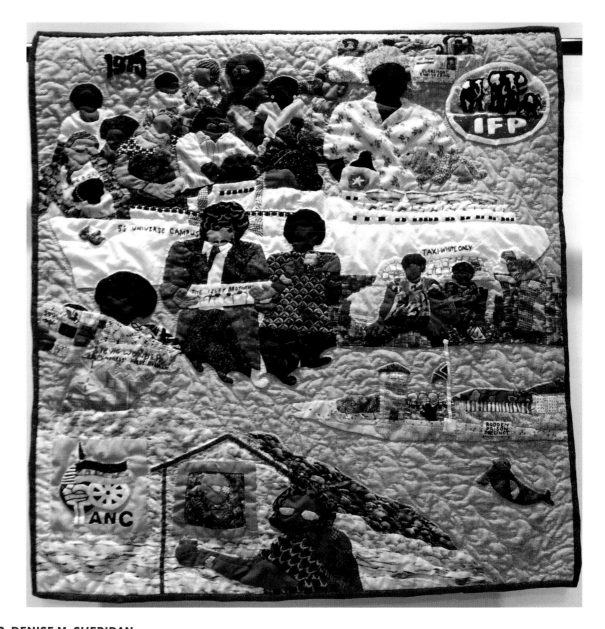

62. DENISE M. SHERIDAN
In the Fortress of the Enemy, You Inspired Us
Arroyo Grande, California, USA | Cotton fabrics; hand appliquéd, quilted, embroidered

In 1975 I visited South Africa as a student; now, nearly forty years later, I made this quilt because Madiba Nelson Mandela greatly influenced my life and the lives of eleven other African American students who visited the country while he was imprisoned on Robben Island. We smuggled Afrocentric contraband to Black South African students and then smuggled their political writings back to the U.S. to be published. Mandela's courage changed the course of all of our lives forever.

Many of the images on the quilt are from photographs I took on that 1975 visit. Hand embroidered on front of quilt: Claremont Engineering, MS Ebony, SS Universe Campus, The Isley Brothers, Taxi-White Only, Stevie Wonder, Fulfillingness' First Finale, 46664, Robben Island Precinct. Hand appliquéd on front of quilt: 1975, IFP, ANC

I believe that art is a powerful bridge to help develop cultural competency skills so desperately needed between diverse peoples and nations. Quilts are a vehicle for centering those so frequently marginalized in the art community, namely women, and more, specifically, women of color.

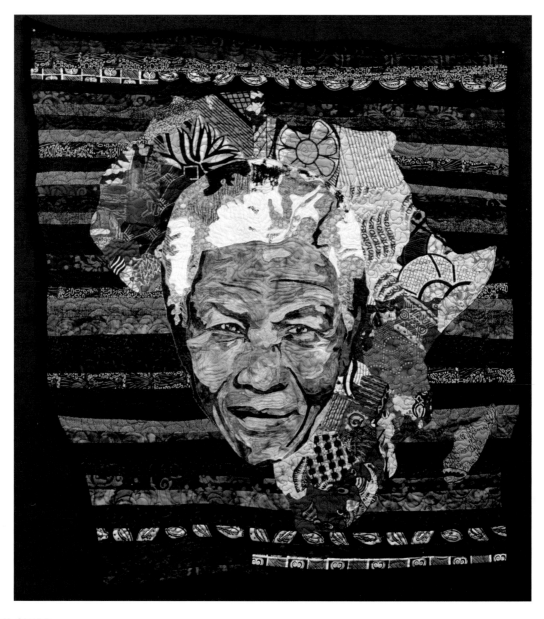

63. APRIL SHIPP
Tata: Father of the Nation
Rochester Hills, Michigan, USA | Cotton fabrics and batting, cotton, rayon, and polyester threads; machine quilted

In creating this quilt I wanted to capture the twinkle in Mandela's eyes and the warmth of his smile. I appliquéd his face with hand-dyed and batik fabrics of rich colors. His head rests atop the continent of Africa that is comprised of 47 countries on the mainland; each country is cut from a different piece of African cloth. The continent flows on a sea of black-striped, pieced fabrics.

In Mandela's Xhosa language, tata means father. Many South Africans refer to Mandela as Tata to show their affection and respect for him; many consider him as the father of their democratic nation. Some call him Tata because they held him so dearly in their estimation that they considered him one of their own family members.

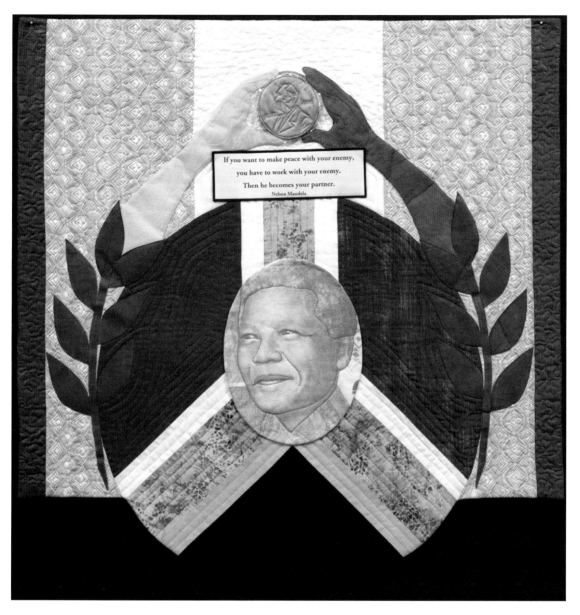

64. CAROLE GARY STAPLES
Peace Mandela, A Tribute to Madiba
West Chester, Ohio, USA | Cotton fabrics and batting, waxed cotton, acrylic felt, fabric paint, and mixed media materials; machine pieced and quilted, machine and raw edge appliquéd

If you want to make peace with your enemy, you have to work with your enemy. Then he becomes your partner.
— Nelson Mandela

Peace, the freedom from oppression and contention is a universal desire. I was inspired to create a mandala for Mandela because of its spiritual and ritual symbol of the universe. Nelson Mandela was truly the universal embodiment of peace, perseverance, strength, and forgiveness.

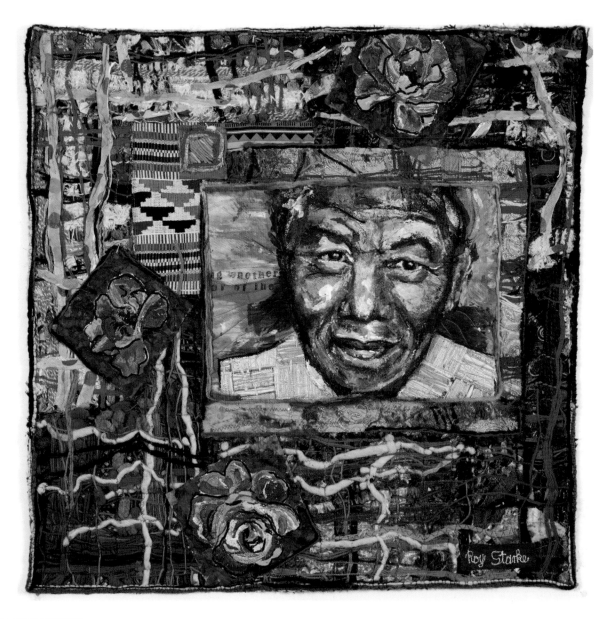

65. ROY STARKE
Madiba, The Face of Forgiveness
Pretoria, Gauteng, South Africa | Kente cloth, cotton blends, paint, embroidery thread, cording made from embroidery thread; stamped, stencilled, appliquéd, vestment cuts, dyed, machine and hand embroidered, machine quilted, tapestry

My joy in creating this quilt was intensely emotional; at times for me it provoked strong emotional distress. I hoped to achieve a visual impact, one that evokes an extremely loving feeling, one that has everything to do with the theme of Mandela and his conscience of spirit. I used a fragmented and complex composition with the placement of Mandela's face in a "box-like" section; the visionary man breaks from the hidden surfaces. This face, the face of forgiveness, is of primeval stature. I also used an ecstasy of color; remember "Free, free at last?" The outlines of frame of the face are in gold, suggesting that he was prince-like and almost belonging to a church order. The roses are a symbol of love and thanks to Madiba; the Kente cloth represents that this great man is from Africa. On the back of the quilt I embroidered an eternal flame; may his spirit live forever.

Quilts should recall human rights and emotions and a deep level of conscience. Needle and thread become instruments for the power of ideas, feelings, and convictions; these are transmitted through fabric.

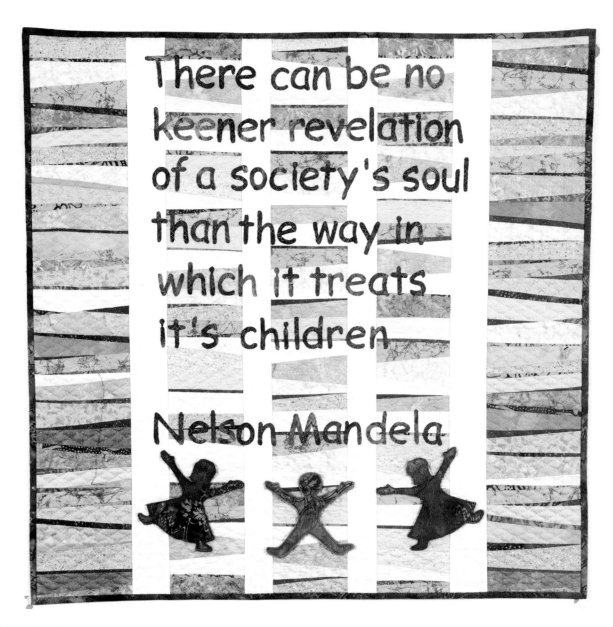

66. JENNY SVENSSON
No Keener Revelation
Johannesburg, Gauteng, South Africa | Cotton, Hobbs Thermore batting, acrylic felt, and Seweeze, Superior, and YLI thread; machine pieced and appliquéd, machine and hand quilted

One of the tragedies of Nelson Mandela's long imprisonment was that he missed the growing up of his own children. After he became President of South Africa's young democracy, he often visited schools and children's hospitals. In 1995 he established the Nelson Mandela's Children Fund that continues to work among the young people of our country.

As a piano teacher and school music teacher I have a special love for children. I have watched my students grow from small children into adults whose skills and abilities are crucial to a healthy society. Children who passed through my doors are now teachers, nurses, doctors, business people, veterinarians, IT specialists, community leaders and so much more.

It is vitally important that we always remember that today's children are tomorrow's adults. In their small hands lies our future. We should treat them with dignity and respect. We should teach values of integrity, and love for fellow humans. We should, above all, recognize that they are vulnerable, and need our utmost care. The words of Mandela on this quilt are a powerful message to every nation, not just South Africa.

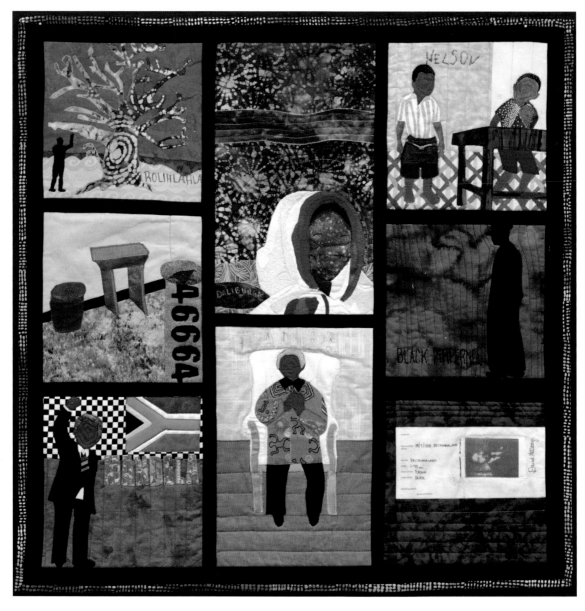

67. FELECIA TINKER
What's In A Name?
Cleveland Heights, Ohio, USA | Cotton fabric, batik, cotton and silk thread; machine pieced and quilted

When starting this journey, the name most familiar to me for Nelson Mandela was simply Nelson Mandela. I then learned that Mandela was born into the Madiba clan where he was given the name Rolihlahla that, in Xhosa, meant literally "pulling the branch of the tree". On the first day of school his teacher gave him the name Nelson; as he writes in his book Long Walk to Freedom, he doesn't know why his teacher chose that name. Mandela was sixteen at the time of his traditional Xhosa rites of passage into manhood and when he was given the name Dalibunga or "keeper of tradition". During his time of anti-apartheid activities and before he went to prison, he used the alias David Motsamayi. Mandela was so elusive about this period of "living underground" that he was dubbed the Black Pimpernel. Upon his arrival to Robben Island prison he was given a new name, the prison number 46664; the number meant he was the 466th prisoner in the year 1964.

What is in a name? A life well lived!

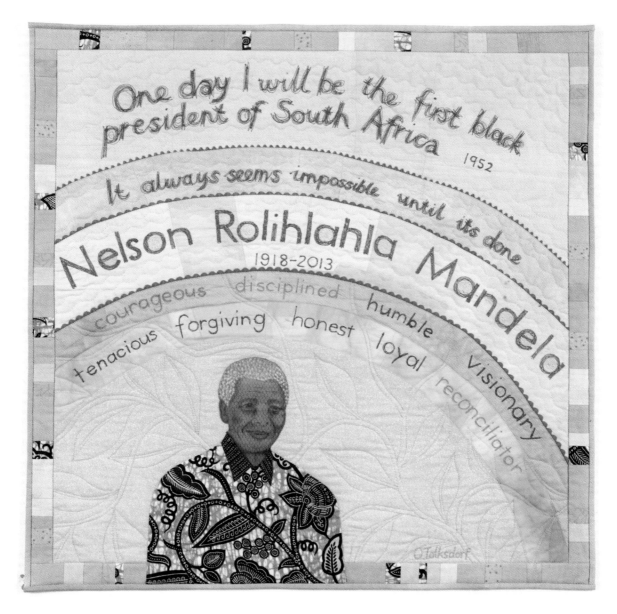

68. ODETTE TOLKSDORF
Mandela — One Day
Durban, KwaZulu-Natal, South Africa | Cotton fabrics, rickrack braid; pieced, appliquéd, freehand machine quilted

Mandela was a person whom I had great respect for, a sentiment shared by so many other people around the world. I admired Nelson Mandela not only for his deeds and actions but also for his thoughts, views, and opinions that he left to the world.

When I planned this quilt I was certain that I wanted to incorporate some of his wise words that appealed to me or that inspired me. It was difficult to decide what to choose because there were so many; I decided, however, to use the following quotes: *One day I will be the first black president of South Africa* (which he said in 1952) and it happened in 2004) and *It always seems impossible until it's done.*

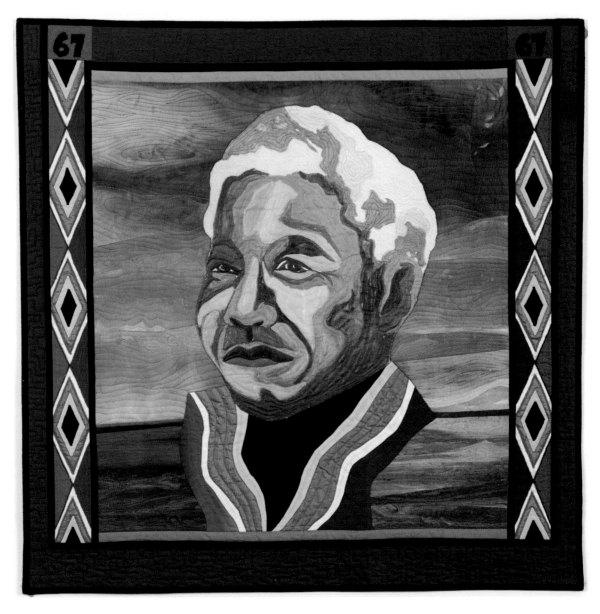

69. ELMINE VAN DER WALT
Ukuqala Okutsha (A New Beginning)
Potchefstroom, North West, South Africa | Hand-dyed cotton, silk, cotton/polyester threads and batting; machine pieced, machine appliquéd and quilted, hand painted

The quilt represents South Africa, a new beginning, from 1994 – 2014. The quilt is symbolic of the new South Africa with President Mandela as the creator of freedom.

It is a depiction of Mandela looking out of a window at the prison on Robben Island at the sunrise over the sea. Seeing the sun rises every morning, he also saw in his mind the sun rising for South Africa and the role he could play. The new South African flag, draped around Mandela's shoulders, is symbolic of the new South Africa – a country for all. I chose a Xhosa name for the title because Mandela is a Xhosa.

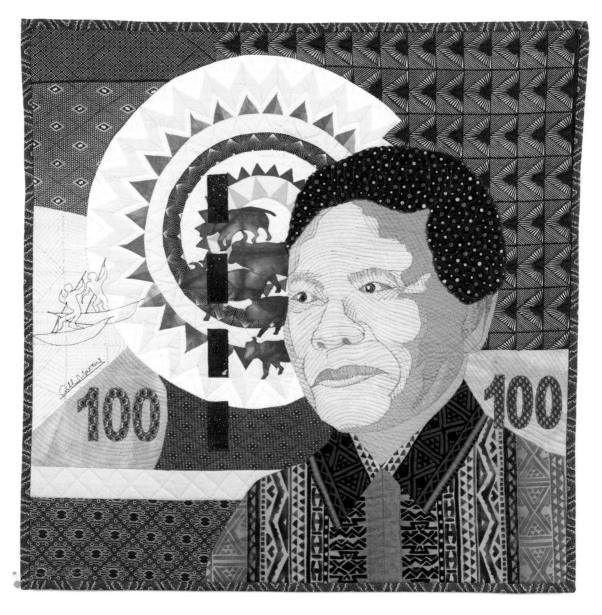

70. BETTIE VAN ZYL
Everyday Reminder — R100
Hermanus, Western Cape, South Africa | Shweshwe cotton and cotton thread; pieced, machine appliquéd and quilted

In my research for a design for this quilt, I looked at many different images of Madiba, trying to find something that appealed to me. Time was running out and I still hadn't found anything that "talked" to me, when I was asked to count the collection money at church. The *obvious* jumped out at me! Of course! The R100.00 note and Shweshwe!

I used a very friendly image of Mandela in an ethnic shirt, many elements of South African culture, geometrical ethnic patterns, and blue...all together on the front of the money note. It made for an interesting construction challenge. I made it especially for this exhibition and used a fair bit of artistic licence as it is *my inspiration* and I do not intend to tender the quilt as legal payment. It serves as a daily reminder of Madiba's contribution to our democracy.

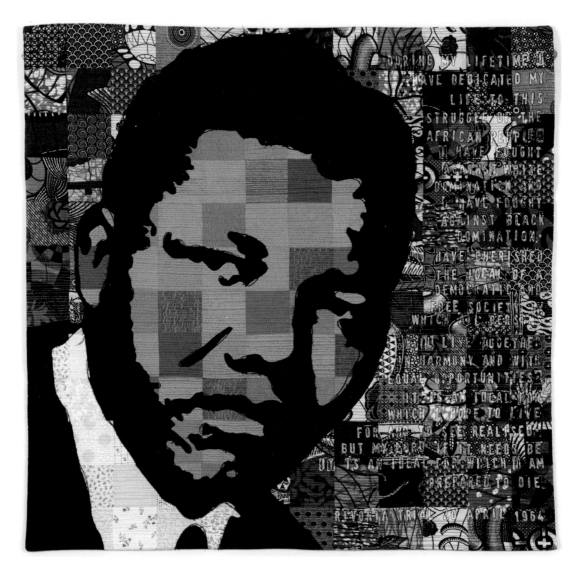

71. DIANA VANDEYAR
Portrait of a Man Who Will Change the World
Cape Town, Western Cape, South Africa | Fabric, paint, thread; pieced, raw edge appliquéd, stamped, matchstick quilted

During my lifetime I have dedicated my life to this struggle of the African people. I have fought against white domination, and I have fought against black domination. I have cherished the ideal of a democratic and free society in which all persons will live together in harmony and with equal opportunities. It is an ideal for which I hope to live for and to see realised. But my lord, if it needs be, it is an ideal for which I am prepared to die.[28] — Nelson Mandela

From reading just the first pages of Mandela's A Long Walk to Freedom, I was captivated by his account of his involvement in and commitment to the struggle. The basic visual element here is a photograph of Mandela taken by Eli Weinberg in the late 50s or early 60s.[29]

[28] Nelson Mandela, statement at the opening of his defence case during the Rivonia Trial at the Palace of Justice, Pretoria Supreme Court, Monday, April 20, 1964. I use wording here that I took directly from the original Dictabelt audio recording in the collection of the National Archives of South Africa as I discovered there were discrepancies in the transcripts and quotes that I researched online.
[29] Used with permission of the University of the Western Cape, Robben Island Museum Mayibuye Archives.

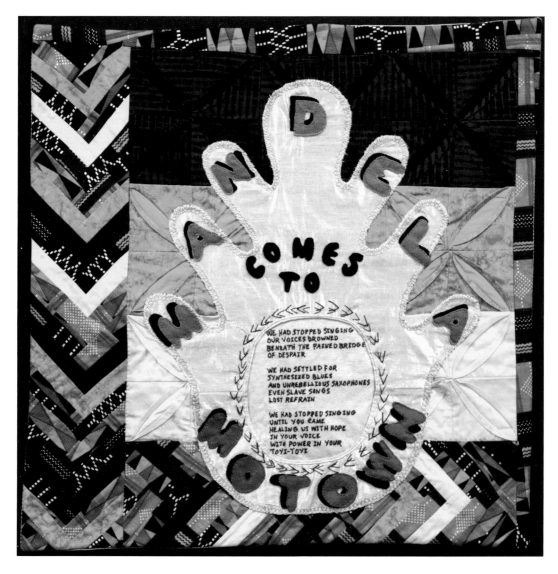

72. HILDA VEST
Mandela Comes to Motown
Detroit, Michigan, USA | African fabrics, batiks, felt, embroidery threads; embroidered, button-hole stitched

We had stopped singing
our voices drowned
beneath the pained bridge
of despair

We had settled for
synthesized blues
and rebellious saxophones
even slave songs
lost refrain

We had stopped singing
until you came
healing us with hope
in your voice
with power in your
toyi-toyi
– Hilda Vest

Nelson Mandela came to Detroit in 1990 shortly after his release from prison. The trip, part of a fundraiser for the African National Congress, attracted forty-nine thousand people who welcomed him at Tiger Stadium, the baseball stadium in Detroit. His speech resonated with love and inspiration and he capped it with a brief rendition of the Toyi-Toyi, a dance of revolution and celebration. I was awed by his forgiving spirit and wrote this poem to commemorate this historic event. In a quilt, the poem has taken on a new sense of permanence.

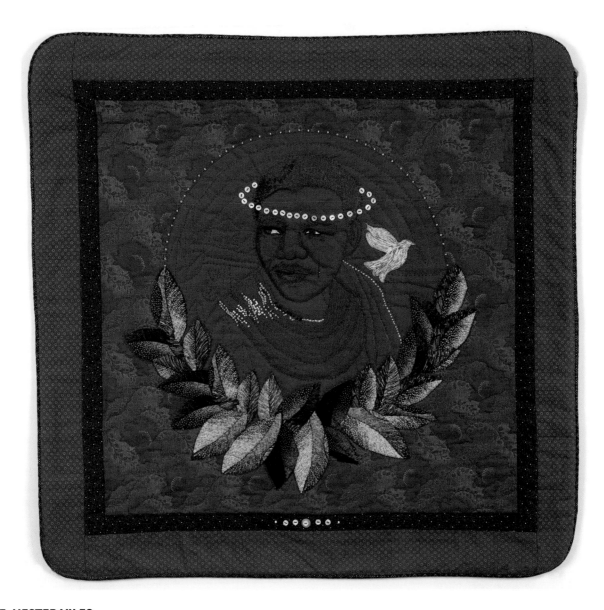

73. HESTER VILES
Laureate
Kempton Park, Gauteng, South Africa | *Three Cats* and *Three Leopards* trademarked fabric by the South African Da Gama Textiles Company; hand and machine embroidered, hand and machine quilted

The design of this quilt was based on the traditional Khanga, (commemorative or political) cloths, made for the African market and worn to depict political affiliation or the celebration of an important event. This specific artwork also references a well-known photograph of a young Nelson Mandela. He wears the beaded collar and robes of the Thembu clan of the Xhosa tribe.[30] Various South African cultures, including the Xhosa speaking people, create jewellery with beads. In the color and patterning of beaded collars the wearer's social and marital status is embedded and is an expression of their identity.[31] Nelson Mandela was extremely proud of his cultural heritage and wore beads on many occasions.

The small white buttons are a typical adornment on Xhosa clothing and the fabric used also alludes to traditional women's pinafores and therefore to Nelson Mandela's great respect for women. A laurel wreath is a well-known symbol recognizing success and victory.

[30] Battersby, John D. and David Elliot Cohen. *Nelson Mandela: A Life in Photographs.* New York/London: Sterling Publishers, 2009.
[31] *Ezakwantu Beadwork of the Eastern Cape.* Exhibition Catalogue. Cape Town: South African National Gallery.

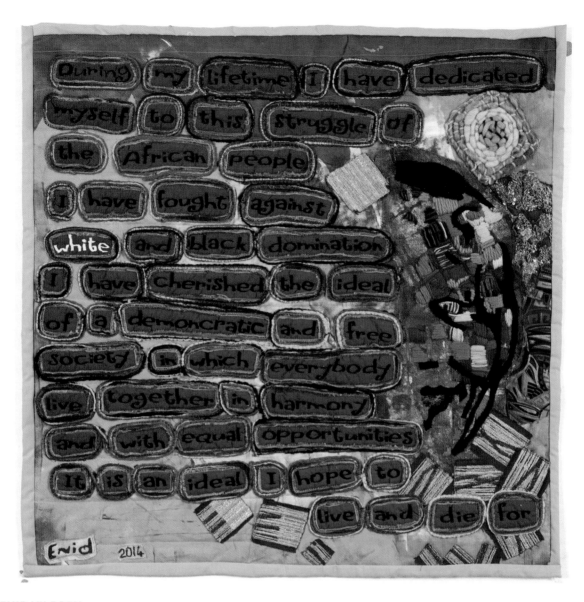

74. ENID VILJOEN
Education
Howick, KwaZulu-Natal, South Africa | Cotton, wool, Hessian, paint; hand embroidered, machine embroidered, machine quilted

I start making this quilt in October 2013 when Madiba, an important figure in our history, was already sick and near death. It was with my compassion for him and his family in mind that I constructed this quilt.

I have used the most powerful quote and put it on a blackboard with Madiba teaching us word for word what he believed and strove for: "Education is the most powerful weapon which you can use to change the world."

I hope to help share this wisdom with the rest of the world.

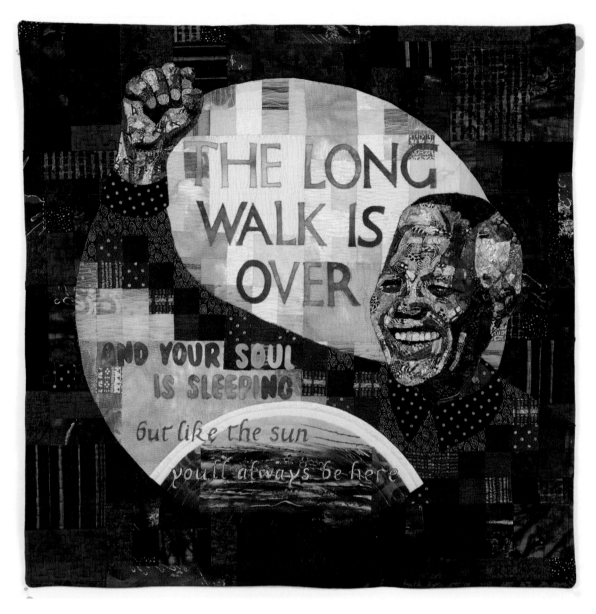

75. SHEILA WALWYN
The Long Walk is Over
Cape Town, Western Cape, South Africa | Cottons; free-motion appliquéd, machine pieced, embroidered and quilted

With the passing in 2013 of such a great South African icon and the feeling of huge loss and sadness that the entire country experienced, this opportunity to create something in his memory came at just the right time.

For the design of this quilt, I was inspired by a song written by a friend of mine, Don Clarke, and Kalla Bremer, whose song 'The Long Walk is Over' was the grand prize winner in the Great American Song Contest this year (www.greatamericansong.com/hall-of-fame). The song popped up on my Facebook page at exactly the time that I was trying to think of a theme/design for my entry, so I figure that was serendipitous. Don kindly gave me permission to use the images and words in any way I chose.

76. JANET WARING
Madiba's Stars
Howick, KwaZulu-Natal, South Africa | Cotton; English paper pieced, machine quilted

This quilt is a smaller version of a similar one I made some years ago to express the joy and celebration of our new South Africa. So when quilters were invited to contribute a quilt I made a version that would fit into the specifications required.

His path was marked
By the stars in the Southern hemisphere
And he walked the length of his days
Under African skies.
— Paul Simon

Nelson Mandela, our Madiba, transformed our dull grey society into a vibrant rainbow.

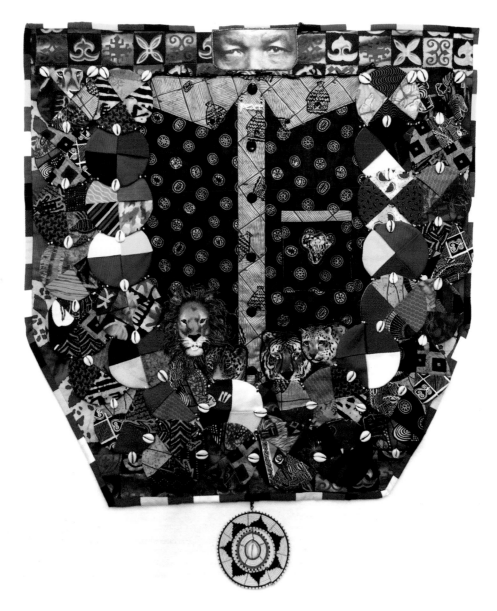

77. SHERRY EVON WHETSTONE
Eyes of Courage: Wisdom From Our Beloved Sage
Kansas City, Missouri, USA | Cotton African prints, batiks, cowrie shells, beads; beaded, hand sewn, machine quilted

I have always loved Mandela's gentle voice and sense of style; that is why I chose to re-create a beautiful beaded African shirt as the focal point of this quilt. He wore such shirts with such class and with indisputable dignity.

Wild cats along the bottom are symbolic of his courage, strength, and endurance. The eyes of the cats are highlighted with beads to make the image "pop" and draw the viewer in for closer inspection.

Nelson Mandela was a wonderfully wise elder and it was imperative to me to include on this quilt some of his famous quotes, thoughts, and messages. I brought in the colors of the African flag in the binding of the quilt. I've also included here packets of spiritual sage from my organic garden as I know that would bring a smile to Mandela's face.

You are wise. You are beautiful and proud. You are respected and missed, Madiba Mandela.

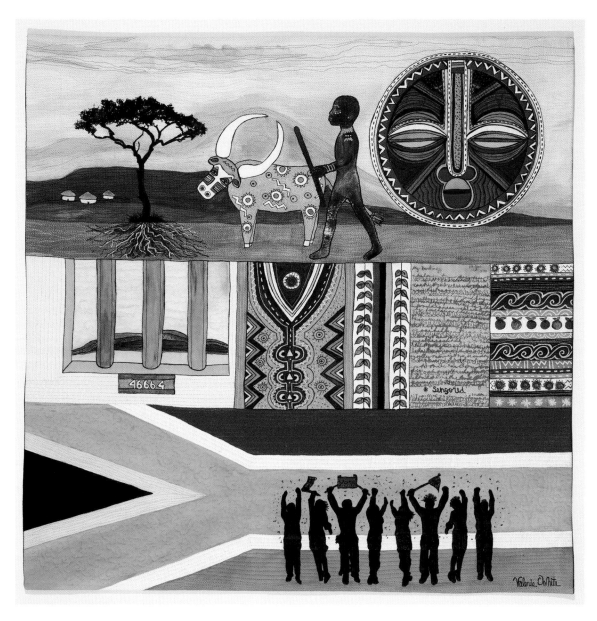

78. VALERIE C. WHITE
Collective Memories
Denver, Colorado, USA | Cotton fabric, textile paint, and silkscreen; hand-drawn, painted, and stitched

It was the memories of home, family, and community that sustained Mandela during his 27 years in prison. In essays written after his release, Mandela writes of being determined to hold onto his "collective memories"; this wise and ancient practice would empower him to survive. In this quilt, I attempted to illustrate components of his life that form "collective memories" for us to remember him always.

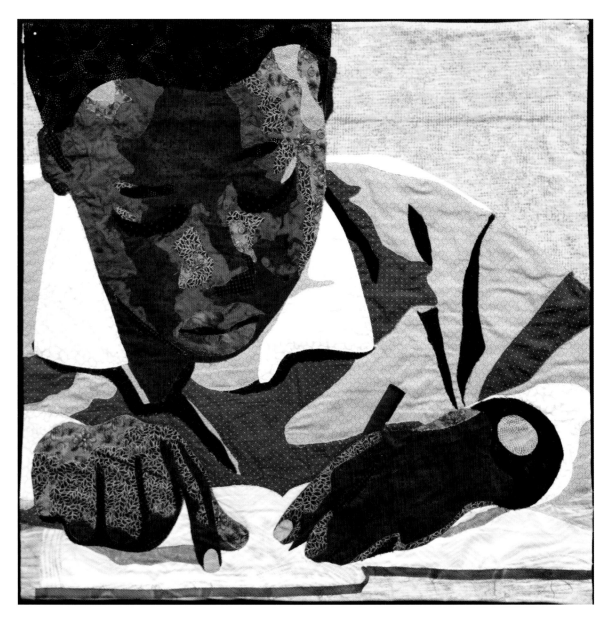

79. LENI LEVENSON WIENER
Who Will Carry On?
New Rochelle, New York, USA | Commercially available printed cotton fabric, cotton canvas backing; raw edge machine appliquéd

Education is the most powerful weapon which you can use to change the world. — Nelson Mandela

For me, this quote resonated and meshed beautifully with the kind of work I prefer to do—it allowed me to focus on the face and hands of a young boy concentrating on his schoolwork. Education for children, not just in South Africa but around the world, will be the way to sustain the work Mandela began in his lifetime. The children of today will be the ones to carry on his legacy in the future and their education will be an important tool for change the world over.

As a former photographer, I am drawn to images that are like snapshots, glimpses into ordinary moments in the lives of strangers. My work is primarily figurative, I like to explore facial expressions and the delicacy of hands as well as body language, which is so universally identifiable and connects us all. I am honored to be included in this very special exhibit and join the creative voices of the other artists to celebrate the life and work of Nelson Mandela.

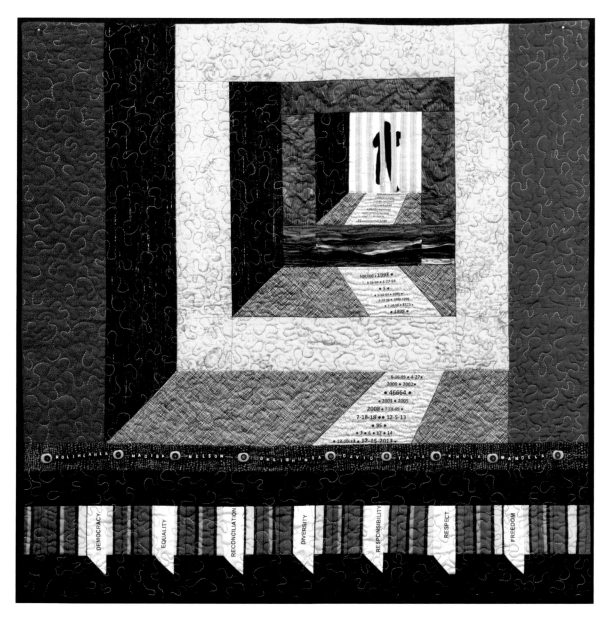

80. SAUDA ZAHRA
Victory of the Spirit
Durham, North Carolina, USA | Cotton fabrics, photo transfer, applique; African beads and bead lettering embellishments; machine pieced and quilted

In this quilt I highlight two pivotal periods in Mandela's fight for freedom, justice, and equality: his incarceration and South Africa's democratic constitution. I captured the timespan between these two periods by layering the attic window quilt block pattern that visually suggests the distance between Mandela looking out into the future, and someone looking in at a new South Africa.

This visual pathway, between Mandela peering through prison bars and the seven pillars of the South Africa constitution, is marked by pivotal dates and numbers in his life and ends at names of those who shaped, nurtured, and grounded the man we know today. The boxing pose against the prison bars creates a powerful image of a man who did not let being in prison stop him from continuing to fight for his country. The South African flag colors evoke feelings of despair, growth and hope.

The quilt speaks to how Mandela survived unimaginable circumstances, thrived in spite of insurmountable obstacles, and achieved victory of his spirit that enabled him to live and die in a free democratic South Africa.

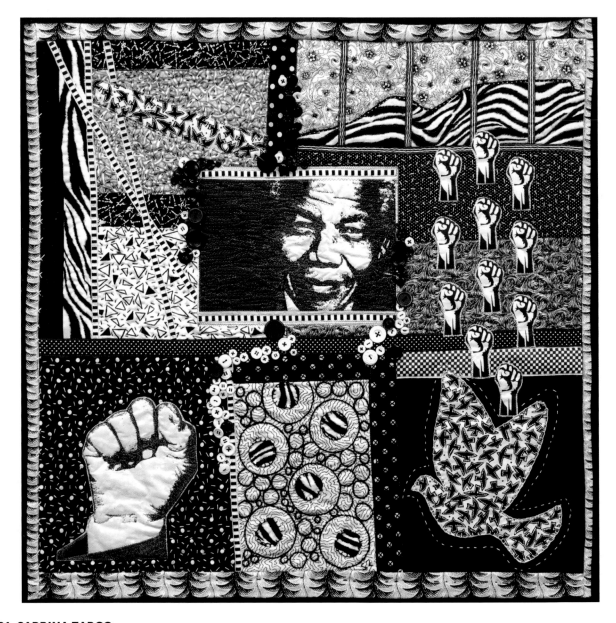

81. SABRINA ZARCO
Solidarity: More Than Black and White
Pecos, New Mexico, USA | Commercial cotton fabric, cotton batting, buttons, embroidery thread, copyright free images, ribbons; raw-edge appliquéd, hand embroidered, hand and machine quilted.

For to be free is not merely to cast off one's chains, but to live in a way that respects and enhances the freedom of others. — Nelson Mandela

This quilt reflects on the life and work of Nelson Mandela. Depicted is the view from the prison cell, the raise fists of the people, dove of peace and freedom, and a portrait of Mandela. The quote sums up the celebration that is the focus of this work.